Do Talk To Strangers

A Creative, Sexy, and Fun Way To Have Emotionally Stimulating Conversations With Anyone

Matt Morris

Table of Contents:

FOREWORD

Excitement. Connection. Love. Those are the three words that linger inside my mind when I think of engaging in a conversation with a stranger.

The word stranger is simply a person you have not yet met, although it has many negative connotations attached to it as if metaphorically speaking, the stranger were a hanger and dangling from the hanger were several strings hanging with a little note at the bottom of each string. The notes read similar to a yellow hazard sign: "Don't talk to strangers because they might harm you," "Don't talk to strangers because you can never predict how they will respond," "Don't talk to strangers because you will end up embarrassing yourself because you will run out of things to say and come off as boring." This is the stigma society has placed on meeting new people that are not already associated with you through friends, family, school, or work. So, that leaves you with minimal opportunity to meet people you actually like, connect with, and feel a deep love for.

In reality, we all are strangers because at some point we did not know our best friend, boss, or the stranger sitting across the room from you sipping on a latte who keeps glancing at you because she is curious about you. She doesn't understand how to strike up a conversation and is secretly waiting for you to approach her to simply say the single most important word to begin a conversation, "Hi." You have a glimpse of hope that if you could just say that one word, maybe something incredible would come out of it. You think to yourself, "I wonder what she is about...maybe this stranger could be an excellent business contact or connect you with the CEO of the company you are dreaming to work for; or maybe she could be your next romantic pursuit as you two drift free from this world, holding hands as she gently rests her head on your shoulder as you two watch the sunset together in the land of paradise.

iv

After a few seconds of fantasizing, your mind talks you out of approaching her with the simple word "Hi," and you begin to think "it's too quiet in here and people will hear my conversation with her and think I am a sleazebag because I am talking to a woman I am attracted to and I will feel embarrassed even though deep down I am not even the slightest bit sleazy"; or "I will run out of things to say because I am quiet, boring and have a tendency to overthink things." At this point, you shy away and choose to look back at your laptop, pretending that she never existed.

This is a simple example of how I used to see the world before I understood how to talk to anyone, and all of the strategies I will share with you throughout this book including two of the most important strategies when engaging in conversation: being curious, and being in the present moment.

My Inspiration: Connecting With Other Humans

As a child, your parents probably told you, "Don't talk to strangers," which was probably smart advice for your innocent little mind that may have taken that lethal piece of candy from a stranger in a parked van without understanding his or her true motive. Now that you've reached adulthood, and experienced the "real world" where life is fast paced, overwhelming, and challenging – especially if you do it alone – you understand that we are creatures of community and connection.

We *need* to feel connected to other humans whether it's the homeless guy on the street that you walk past everyday on your way to work, or your seat neighbor on the bus sipping on a cherry Slurpee, or the man in the grocery store whom you find attractive that is also shopping for items to put in his salad for his evening get-together.

In order to connect with anyone, we have to challenge the "*Don't* Talk To Strangers," belief that our parents instilled in us when we were children, and replace it with "*Do* Talk To Strangers," or else we'll be in a lonely place lacking opportunity, friendships, and incredible

experiences.

The information you are about to learn is not taught in schools, although it should be because effective conversations are one of the most important subjects for networking and connecting with others. The strange thing is that even though we need to be connected to others, we are also creatures that have a fear of approaching others because we are afraid of the unknown, and cannot totally predict how the stranger that caught your eye will respond to your approach, or the first words that pour out of your mouth.

After years of initiating thousands of conversations both for experimental purposes and to build amazing connections, I discovered the key ingredients and created my personal method of how I went from a total antisocial human to a socially competent being who gets excited when it comes to meeting new people, and turning any small talk conversation into a meaningful and emotionally rewarding conversation, filled with powerful and unforgettable stories that turn into friendships, romantic relationships, and lucrative business opportunities.

Do Talk To Strangers is divided into 3 sections, starting with _Small Talk,_ which gives simple, exciting and mildly wacky strategies that will show you how to have fun with every small talk conversation. The second section _Meaningful Conversations_ gives 10 simple steps to creating an amazing conversation with any stranger – anywhere, anytime, anyplace. Lastly, the _Method To Storytelling_ Section gives you 10 steps to take any simple fact that happened in your everyday life, and turn it into a powerful, emotionally stimulating, and unforgettable story.

Once you reach the end of _Do_ Talk To Strangers and implement the simple, fun and sometimes ballsy strategies, you will see and feel a remarkable difference in the way you meet and interact with strangers.

SECTION I: SMALL TALK

Introduction

Small talk. It is an uncomfortable, awkward, superficial way of communicating that is considered a waste of time and at the same time, a necessity to communication. It is more than an art. It is a science. When you combine the two, it becomes a mixture of colorful options in which you can choose what to say based on your creativity, personal experiences, and the method (or formula) that will soon be laid in front of you.

Take life by the balls and jump into the fire, initiating small talk or words to ignite a conversation to reach the point where a listener feels compelled and excited to talk to you, that is…if you want to continue talking to this person. If you don't learn to do this, you'll watch your life sail by and then you'll wake up one day thinking, "What if I had talked to this of that person…? Where would I be today?" These thoughts surround the small talk that ignites 99% of all new relationships; networking events to advance your career; small talking with your boss, clients, or even your neighbor to fill the awkward silence as you pass each other every few days.

Small talk can be a tailspin of regurgitated jumble that exits the mouth on a daily basis; or it can be words which flow in a fashion similar to a breathtaking Monet painting that leads to fulfilling conversations and a life filled with possibility.

Most people engage in small talk without thinking about it. For example, whenever you enter a grocery store and make eye contact with a worker and he asks, "Hi, how are you?", the words are simply on autopilot; and your autopilot might be to say "Good." Then you go on with your lives, never really making that genuine connection that makes life so wonderful and rewarding. What if you were to turn the small talk into a simple system and connect with him in a matter of minutes so that each time you entered the grocery store he knew your name, and was happy to see you?

What if you had the ability to connect with the store clerk about how "strange" the weather has been with the ungodly amounts of rain in the past week, and become friends in a matter of minutes; or the next time you see your neighbor on his lawn he invites you over for dinner with his family instead of just saying "How's it going?"; or what if the next time you're in a dentists' waiting room you choose to have small talk with the stranger next to you and fill the empty space of worrying thoughts with ones of how you both own Weimaraner dogs and the new doggie park that just opened near your home?

The ability to connect with others and form relationships with others keeps life fun, adventurous, and exciting. Therefore, mastering the skill of small talk is a challenging one, yet one that is admired by many, and important for living and being successful in today's world.

In the *Small Talk* Section you will see you how to talk to anybody, win friends and always have something to say. You will discover a plethora of tips, insight and wisdom about how you can become a master at small talk.

Some of the strategies offered in this book might seem totally off-the-wall, wacky, or even mildly humorous, asking you to step way outside of your box. I encourage you to try each of the strategies with a perspective of "just having fun," not only because it will exponentially improve your small-talk abilities, but more so because you will grow as an individual and determine what works best for you, and what does not.

By the end of this book, I want you to look back at these questions, and think to yourself, "Small talk is simple, fun, and improves my life everyday." Let's get started!

Chapter 1:
Put On Your Small Talk Helmet

Small talk is like the starting point to a maze. You entered the maze and now you have to decide which route is best for you. You can choose Path A and use it to let the time pass; Path B to fill any dead air and avoid awkward silences; or Path C to lead to deeper, meaningful conversations.

In most cases, it is with a person whom you just met or have had very little previous interaction. It is how conversations begin when you are sitting next to someone in a waiting room, a classroom, or on an airplane. The words, "Hi. Where are you from?" can open a door to a thousand conversations, or you can decide to shut it depending on how the person responds and what you want.

Small talk is the core essence of how 99% of all relationships are formed. From a random-topic of conversation such as the warm weather in San Diego to a profound, meaningful one such as why there are still bits of racism around the world, or how technology is killing "natural" communication. The beauty of conversation is that it stimulates a wide range of electrifying emotions, opening minds and bringing a new level of understanding between people and cultures.

Small talk sets the foundation for building a deep, meaningful connection with another person. Therefore, it is also an important skill that people should master so that they can simply reach in their back pocket to use as needed – anywhere, anytime, anyplace.

Before we jump into the tips and strategies for small talk, let's first take a look at the value of small talk. Here are a few reasons why making small talk can enhance your life.

- **Small talk will boost your intelligence.**

 According to research done by the researchers at the University

of Michigan, it is said that a friendly socialization can enhance one's ability to comprehend and solve problems. This is proven by Oscar Ybarra, a well-known psychologist. He said that social interactions let people read and understand the minds of other people so that we as humans can function more effectively in society.

It also forces you to think faster. When someone asks you a question when you're not expecting one, it will require you to think on your feet to organize and present ideas rapidly.

- **Small talk will improve your self-confidence.**

 Approaching strangers and knowing what to say is a challenging task. However, by making small talk a regular part of your day, and repetitively engaging in small talk, your confidence in your social abilities will significantly increase. In addition, small talk will give you the opportunity to connect with others on an emotional level, increasing your confidence in your ability to understand others.

- **Small talk will make you attentive and a better listener.**

 If you are conversing with other people, then you need to direct and focus your attention on them, and be in the present moment. It is important to *be* with the person and do your best to *feel* and *understand* what point they are trying to get across. You'll be amazed at how much your listening skills improve, especially if you practice doing this with every conversation for the next 30 days. People want to be heard, understood, and feel that they are not alone, and by participating in small talk this is what you can give to others.

 After a few months of participating in small talk, you'll notice that you have an ability to predict what others are about to say as well as read deep into a person to determine if there is

something behind what they are saying. For instance, if you ask "What do you think of this rainy weather?" and they respond, "I love it." But you feel, based on your thousands of small talk interactions that there is something else going on because you heard a slight jump in that person's tone of voice as they said the word "love." In addition, you read and listen to what their eyes are telling you, and you feel there is something much deeper going on. From this point, depending on your how deep you feel like venturing, you can decide to get curious about what their comment is *really* about, or you can simply leave it as it is, smile, and walk away.

Again, this is a deeper, more advanced level of listening that comes with a commitment to listening, hearing, and understanding what the other person is trying to say. Of course, the more you practice, the faster you will see improvement.

- **Small talk will brighten days.**

Have you ever been in a room filled when acquaintances and felt drained, like you didn't want anyone to see you, and especially did not want engage in conversation? Then all of a sudden someone walks in the room and looks at you with a smile on his (or her) face? At first you think, "I hope he is not looking at me," and then "please God do not let him talk to me."

Then he does. He says "Hi. How are you?", with a bright shiny smile and gleaming eyes. For some strange reason, as you say, "I'm doing pretty good," you get a sudden rush of excitement running through your spine. You immediately begin to feel better. You aren't sure why or how it happened. But, you feel significantly better as the seconds pass and you connect with him. This is a tiny example of what small talk can do for you and other people.

The Fastest Way to Improve Communication Skills

Some people are born with natural charisma to make others melt with each word that comes out of the mouth. Others are born with the charm to convince others to follow them to the end of time. While some are born with the natural social confidence to feel completely confident being themselves in social settings and realm of anxiety about what others are thinking about them doesn't even come into existence. Whereas, 99% or us are not like that. Most of us need guidance to improve our skills so that we can look as smooth as the "naturals."

It starts with the habits and beliefs that have been manifested into your mind such as:

- How you *believe* society will respond to you socially

- Your *belief* in your ability to know what to say

- Your ability to show that you are another human being who has something to offer others. In return, people will give back to you – and now it is time to grab the reins and learn *how* to small talk.

Habits: The Good, the Bad, and the Ugly

Habits are mentioned here because they are important in forming the person you are and the person you are becoming. They are the patters and beliefs that you've trained both your mind and body into believing. Some of the habits have turned into judgments and assumptions based on others' experiences, as well as your own. Good and bad ones develop from our own beliefs, and the beliefs of people who have helped to train our minds such as our parents, teachers, and friends.

Habits are mostly created from our own experiences. When something feels good, we have a tendency to keep doing it over and over until it eventually becomes a good (or bad) habit. These vary from smoking

cigarettes, to taking out the trash every Wednesday, to making small talk with the person standing in front of you at your favorite coffee shop. It's really a risk vs. reward scenario. Is the risk or reward higher? If the reward (or pleasure) is higher than what you are risking, then the first step of habit formation has been created. From this point, it is repetition that determines whether it will become part of your closet of good and bad habits.

It generally takes 30 days for a habit to form. Therefore, if you were to make small talk with a stranger in front of you at your favorite coffee shop every day for the next 30 days, your small talk abilities will significantly improve. Subconsciously your mind will tell you what works and what doesn't based on the responses you get from the other person. If a person responds favorably, your mind will toss that scenario into the "things-that-work" category, and if you get rejected or shutdown, your mind will throw the scenario into the "things-that-don't work" category. From that point, you can either avoid scenarios like that for the future because it is uncomfortable, or you can be like a scientist and figure out what went wrong so you can improve next time, which I recommend because the reality is that life is an experiment. You never know what will happen (especially in social situations) unless you try it out. Once you try it, then you will have clear-cut evidence that it does or does not work.

With each new social interaction, your body and mind will either reward you with a good feeling or a bad one.

Chapter 2:
The Best Locations To Unleash Your Small Talk Skills

Location, location, location! That is half the battle. If you are going to meet someone, you need to know where to meet him or her. You also need a purpose of who want to meet, and why you want to meet them. Once you are clear, you can select a wise place to meet the person you are looking for. There are so many times when people attend networking events, or go to a specific location in hopes of "meeting someone," without any details or specifics. This is where specificity is worth a million dollars. If you know what or who you are looking for, you will save hours (days, months, years) of time and hardship. The reality is we only have so much time, so use it wisely.

Meeting Locations:

1. **Coffee Shop:**

 People go to coffee shops to relax, maybe chat it up with someone new, and of course get a little caffeinated. Feel free to talk to someone new in coffee shops for 3 reasons:

 - They will be more receptive to approaches because of the unintimidating environment

 - They are waiting for you to talk to them because if they didn't then they would simply stay at home

 - It is a simple environment to practice meeting awesome new strangers.

 Next time you are in a coffee shop, start a conversation with someone new just for fun to see where it takes you.

2. Grocery Store

If you're looking to meet friends in a grocery store, then you probably either love food, are health conscious, or looking for someone to cook you dinner. This is a fun place to start innocent conversations, and get excellent food recommendations from fellow customers.

3. Laundromat

It's easy to chat it up in the L-mat. First off you will both be waiting for a lengthy period of time until the suds get washed into each of your wardrobes, so why not small-talk it up for a bit? It will make the time go by much faster too.

4. Gym

If you're going to the gym, then you know all the other people are in there for one of three reasons: they want to stay healthy and maintain shape, want to lose weight, or put on some muscle and get ripped. Having this similar purpose for going to the gym is a great way to establish a commonality. Of course the most obvious way to start a conversation in a gym would be to ask someone for a "spot," or advice on how to build muscle. However, in the gym you'll notice that many people wear business brand shirts such as for the company they work for or the college they went to, or a military t-shirt, all of which offer great conversation starters.

5. The Street

In big cities, the street is an amazing place to meet a wide variety of people. You can have 25 new conversations in a matter of only 2 to 3 hours. It is a great way to broaden your perspective on how interesting our world is and how it is made up of so many cultures and nationalities – only to realize that although we may look much different, we really aren't.

6. **School**

This is easy an easy location to meet people as you will likely see them at least a few times a week. Although it can get complicated if your bring romance into the picture due to the fact that again, you see them often.

Talk to your seat-neighbors to see what they are about and what they do for fun. If you spot someone walking by that looks interesting or that you're curious about, say "Hi," and ask your curious question, with the emotion you are feeling. For example, "I'm a little nervous talking to you because I normally don't talk to strangers, I wanted to ask you...(ask your curious question)."

Or "I'm curious, how come you like the Dodgers yet you live in Florida."

If you like them, invite them to do something you both like. Simple right?

7. **Adult Sports Leagues**

Sports are one of the best ways to find friends. You are both committed to having fun and playing on the field. Why not find other interests and take it off the field to have fun elsewhere too?

8. **The Mall**

If you need to go shopping, or need shopping advice...the mall is the best place to go. Women, especially love to participate in a man's clothing quest, and some men enjoy shopping too. The best strategy to start a conversation in a store is to say, "Hey can I get your opinion really quick. Which do you like better (hold up shirt A), or (hold up shirt B)?"

From that point you can decide whether you want to continue

11

the conversation on not (based on the one she or he chooses). Have fun with it.

9. Concerts

Concerts are fun environments. Although they can be loud, they can also be excellent ways to meet new people – especially outdoor concerts where you really can just walk up to anyone and start a conversation.

10. Bar

The alcohol is flowing as people are getting more open, relaxed, and even a little tipsy. The environment is getting more social and the volume keeps climbing each hour. Due to the fact that people are more relaxed, it is easier to talk to people – that is as long as you don't mind the loud people and music. Test it out because it can be fun, and you might meet an interesting chap or two.

11. Volunteering

If you are volunteering, you've got a huge heart and the person next to you most likely does too. What a wonderful place to meet somebody with similar interests – anything from wanting to make a difference, to helping less-privileged people out, to simply giving your time to help out the community.

Also, if you're feeling up for it, go ahead and make small talk with the customers (of course if it's not busy, and you don't have anything work-related to do). It's a great way to practice and make good use of your time. Plus you might meet your next girlfriend, or someone who can show you a good time.

12. Church

With church, similar to volunteering, you have a similar spark of interest based around your religion. Maybe you are just

curious and wanted to find out more about a religion, or you are a regular church-goer, whatever it is, it is an easy place to just say "Hi, how are you?" introduce yourself, and begin using your small talk skills.

13. Meetup Group

Thank goodness for the Internet…and Meetup. If you haven't heard of meetup, then I don't know where you've been hiding the last 10 years. And if you haven't tried www.meetup.com, then you should. It's an incredibly easy way to meet like-minded individuals. What's a better way to find friends than through hobbies you already enjoy?

14. Book (or Movie) Club

Some people like to read. Some people like to watch movies. This is another easy way to meet new people that have similar interests.

15. At Work

Talk to your coworkers. It's as easy as that. Say "hi" to a person walking down the hallway and find out who your co-worker (or building mate) is. Maybe he's your future bestman at your wedding; maybe he is someone that you will eventually have as a business partner; maybe he's someone who can watch your children (or dog) next weekend. Who knows? You can only gain from engaging in this interaction and learn about others.

16. Airplane

Due to the fact that you are required to sit next to another person on airplanes makes it perfect for conversations. In that case, open the "conversation can" and see what's inside. See who that person is next to you. You might meet someone who can get you backstage passes to a Rolling Stones concert, or

someone who has a spare bedroom at his house in Copenhagen, Denmark.

17. Hotel

If you're a guest at a hotel, talk to the employees and guests. In most hotels (and hostels) there is a lobby where guests can congregate and make small talk. You can freely converse in the lobby and order some coffee or food. It is an excellent to start a small talk conversation with one, and you may make a good friend.

Chapter 3:
Your Voice Speaks Louder Than Your Words

Your voice gives you an image. You could have the looks of Johnny Depp with a voice like Kermit, or look like Michelle Keegan and have a nasally voice similar to Mila Kunis. Even though you might be a tall, lanky, person who is smiling and happy 99% of the time, your voice can make you appear as a short, beefy, tired person. You have two options – you can either embrace your voice and accept it as it is; or you can make small changes to make it sound more attractive to yourself and others around you. In this chapter, you'll learn strategies to do both.

Everyones' voice fluctuates slightly from time to time depending on their mood because emotions affect the way your voice sounds. For example, maybe you're at work, feeling tired because last night you kept tossing and turning because you kept thinking about how you want everything to be "perfect" for your guests coming to town this weekend. Therefore, people will hear the tiredness in your voice.

On the other hand, if you had gotten that glorious cup of 7-11 coffee, then chances are your mind would be firing at 1 million volts per second, and your words would be coming out at rapid-fire speed. The point being that everyone has the ability to slightly alter aspects of their voice based on how they are feeling and it's important to understand this about yourself so that you can place yourself in (or take yourself out of) situations where you know your voice will be an asset.

Some people have a "professional voice" when at work, and a "more relaxed, playful voice" when at home. I'm not talking about completely changing your voice like Robin Williams in Mrs. Doubtfire. I'm talking about slight variations to the way your voice sounds.

Voices Around You

A persons' voice (and accent) will sound similar to the people he or she grew up with. Notice that a person who moves from a foreign country will have an accent that sounds like the people in his home country; whereas if he lives in another location (where people have different accents), his voice will mesh and become a combination of the accents from the two places he lived. For example, if this man was born in Japan, and grew up in England since the age of ten, his voice will assimilate and transform to what he hears is the "correct pronunciation" in England based on the positive responses he receives from other people. Therefore, his voice will have a mix of a Japanese and English accent, and constantly get the question "Where are you from?" simply based on his unique voice.

In addition, if you're a woman who grew up with your mom, you'll notice similarities between your voice and your mom's – you may have noticed that when people called looking for your mom, they mistook your voice for hers.

Wherever you are – at home, on an airplane, or a coffee shop - take a moment to listen to the voices around you. If it is quiet where you are, turn on a television, radio, or step outside to listen to people talking. Now close your eyes for a few minutes and just listen to peoples' voices. Put an image to each of the voices you hear.

- What are you imagining? Do you imagine a tall, middle-aged woman with brunette hair who's from New York City who is in a hurry to get on the subway? Do you imagine a petite, confident, blonde-haired woman who makes sure she is heard every time she talks by the way she pronounces her words?

- Now, take a look at what the people look like. Were you correct?

* Now let's take a gander at your voice. It's best if you have a something to record your voice like a computer program, or a voice recorder (or even a video camera). If you don't, just close your eyes and take a few moments to listen to your voice as you answer these questions. Again, if you have something to record your voice, go ahead and begin recording.

Two New Strangers

If you are feeling extra-creative today, have fun with me on this next strategy. Imagine you just walked in a room and you've spotted two strangers who you are required to talk to. The following is an example you can use to prepare yourself for any future uncomfortable or intimidating small talk situations. The point is to record your voice to see if how you sound in order to see if there is anything you'd like to change. For this example, let's give these two strangers the names Bob and Jessica.

- The first person is a man named Bob who is a burly man, with a long beard and shaved head, standing 6'5 tall, looking slightly intimidating. He appears to many people as intelligent due to his sleek business coat, deep raspy confident-sounding voice, and how the words just seem to naturally flow out of his mouth every time he speaks.

- The second person is a beautiful woman with wavy-blonde hair. Her name is Jessica and she comes off as slightly intimidating, especially after you notice how attractive she is to you. In fact, she has intense and powerful looking eyes.

Those were two examples of characters I created on the spot. Go ahead and create your own Stranger, and give him or her a name. You can use this "person" over and over again, until you feel comfortable (which normally takes a few days). After you are comfortable, you can use him or her to help you in uncomfortable situations. For example, if you feel nervous or anxious at a small talk event, imagine that "Bob" is

17

with you to support you and give you that extra boost of confidence that you need. Try it and watch how your confidence goes up.

The Hairstylist

Another effective approach is what I like to call "the hairstylists powerful question technique." Haircuts often become a process of dishing out family dirt, affairs, and inner-conflicts that we would not even tell our closest friends. It's almost like your hair-stylist becomes the listening ears that you need for the next 30 minutes.

Sometimes I think hair-stylists should win a "Questioneer of the Year" award. Why? Because they know how to small-talk and ask questions to you that get you chatting it up, and before you know it your haircut is over and you've discovered that you need a career shift, you want to go to a counselor to resolve some marital issues, and that your boss is an even bigger a**hole than you previously thought. The questions asked are sometimes similar to the way a life coach asks them – open-ended questions that get to the heart of what matters.

One interesting thing is that you are talking to the mirror and usually looking at yourself, not the hairstylist. Therefore, there is a sense of ease and comfort to just talking and believing that someone is listening. It's not responses that you are looking for, instead it's simply an open space to talk and be heard, similar to if you were talking in the mirror which brings me to another strategy to practice small talk, or even coach yourself to see what comes out. You can even keep a notepad by the mirror to jot down a few thoughts.

Speaking of thoughts and questions, there is an incredible book titled _The Coaching Questions Handbook_ written by Tim Hansen that gives 150 deep, powerful questions that I highly recommend taking a look at because they will give you insight into your life similar to the way a hairstylist or life coach would. You can even take some of the questions you like and use them at your next small-talk venture. It can often be seen as a therapeutic unleashing session.

In this next section, you will be given strategies for answering the five most-common small talk questions that you need to have answers to. You will be given simple techniques that will separate you from 95% of the population.

Chapter 4:
The 5 Most Important Questions You Need To Answer

Now (with your recorder on) answer these 5 common small talk questions as if you were talking to Bob or Jessica (or a character you created).

- What is your name?

- Where are you from?

- What do you do?

- Who are you here with?

- What do you do for fun?

After you've answered, and recorded all the questions, play it back and see how you feel about the way it sounds. Pay close attention to your voice. How did it sound? If you could put an image to your voice, what would it look like? Did you talk too fast (or slow)? Keep these thoughts in mind for the next section because you will learn how you can adjust your voice to sound the way you want it to sound.

Do this task one more time and add these simple strategies to each of your answers.

Where are you from?

Add something unique, or informative about your city when answering this. For example, don't just say, "I'm from Fresno." Say, "I'm from Fresno, the city where the raisins were first founded, as well as one of the largest blues music festivals in the nation."

This opens the door for something interesting to talk about and the listener will be much more likely to remember who you are by associating you with those unique facts.

What do you do?

If you give short one or two word answers, it is time for that to change today. For example if you are a computer programmer, instead of saying, "I'm a computer programmer", you can say something that the general population can relate to such as "I create computer programs to make it easier for children to learn a foreign language" (or whatever niche you work with). The key is to be specific to whom you are helping, and how you are helping them.

By doing this, you will be speaking the same language so that the listener can understand what it is that you spend a majority of your hours doing. If you had just said, "I'm a computer programmer," the response you'd receive will be most likely negative, only because most people do not understand what a computer programmer is or does, not because their nose is too high up in the air to even acknowledge it.

So go ahead and take a few minutes to create a new sentence or two of what you do.

- Who do you help?

- How are you helping them?

Who are you here with or How do you know each other?

If you are with someone, simply introduce the person and give a unique fact about him or her. For example, "This is Jerry. He's been all over the world and just got back from Africa last week." Or "This is Sally. She works with students with disabilities, and won the teacher of the month award two months in a row."

It is key to say something unique about the person your with because it makes the other person look good (and they will appreciate it) and you'll sound like a humble person who people want to connect with. If you don't know much about the person you with – no problem – ask them to tell you something unique about them.

21

What do you do for fun?

Simply come up with a few things that you enjoy doing in your free time. Whether it's golf, catching the latest flick, or meeting new people in coffee shops, make it sound interesting so that people can understand what you do for fun. When answering this question, it is key to ask yourself "Why do I enjoy doing this?"

For example, why do you play golf? Therefore, instead of just saying "golf" you can say something to help the listener understand why you play golf. You could say, "I like hitting the golf ball around with a few friends. It's good exercise, great to be outside, and I'm playing in the local tournament this July."

By adding these 5 small-talk tips to your bag of conversation skills, you will be ahead of 99% of people out there.

Once you have added the new strategies, go ahead and record your responses to the questions again. Play it back and see how you sound.

A person's tone of voice can either make or break the first few seconds of your small talk initiation. Therefore it is important to get your voice where you want it in order to display passion, enthusiasm, and confidence in yourself – which will be discussed next section.

Take note of what you like and don't like. Pay attention to your voice and the way it sounds. If there is anything you'd like to change about it, then it is time for you to do something about it.

Maybe you have a strong accent, or maybe you feel your voice is too high or too low, or you have a lisp that you don't like. Or maybe you talk too fast because you're a visual person and you don't have enough time to describe everything you see in which case you speak too fast and it is difficult for others to understand you. Each of these limiting beliefs will negatively affect your confidence in your ability to communicate, and will affect the way people respond to you.

Chapter 5:
The Small Talk Skills That Will Set You Apart From Other Humans

1. Listening skills are in great demand.

Listening is hand-down, no questions asked, one of the toughest things to do. Why? Because it takes genuine effort, and most people would choose simplicity over difficult tasks. Therefore, since it takes less effort to say what's on your mind, or what's bothering you, or how awesome you are, most people choose to talk rather than listen.

However, if you choose to be one of the rarities who genuinely listen and be curious about people, you will be a hit. You will be amazed at how many strangers want to keep chatting it up with you once you initiate a conversation. Once the strangers around you realize that you are one of those "aliens" who actually listen, you'll be shocked at how many people like you and want to be your friend - you may even get invited over for dinner.

Another reason why listening is challenging for us is because of all the distractions that the tech-geniuses have created. Mark Zuckerberg, Bill Gates, Steve Jobs have created these brilliant little things such as Facebook, Computers, and iPhones that can easily be one of the biggest distractions and nuisances today. Some people are actually addicted to their Smart Phone (http://www.webmd.com/balance/guide/addicted-your-smartphone-what-to-do). The point being that when participating in small talk (especially with someone new); it is imperative to turn off all distractions, and turn on your ears, eyes, and intuition.

* Challenge: Just for fun, the next time you initiate a conversation, and begin small talk, try limiting the word "I" from your vocabulary. I like the "I:You" ratio to be 3:1. Don't talk about yourself at all. Give your mind permission to be totally silent and just be completely curious and amazed at the person standing right in front of you. I like the formula

of first ask a question out of curiosity, then have a small response (not more than 30 seconds – 1 min), and ask another question because you are curious about the person you've chosen to spend your time talking to.

As I've mentioned previously, it is key to leave all your previous and future thoughts in front of the door before entering a room. This will allow you to be in the present moment and let your mind flow, instead of getting anxious about the future, or stressed-out about the past. If this is new to you, or you haven't mastered it yet, take a look at my book _How To Live In The Present Moment_. You'll get 6 steps that will show you how to easily access the present moment.

One of the greatest gifts we can give to others is our ears, eyes, and heart for listening; to show that we genuinely understand, and are acknowledging the beautiful human being standing right in front of you. You may even begin to notice how quickly people will fall in love with you, by simply listening and understanding.

2. Not too fast, not too slow. Right the middle.

Talking at a rapid pace often makes the listener feel rushed. You may even notice that the listener didn't catch what you were saying due to your ability to "rap" what you're saying. In addition, it will give off the impression that you are nervous and unsure of what you're talking about.

Whereas, if you talk too slowly it can bore the listener, and he or she will begin zoning out and thinking about how amazing it would feel to simply lie in bed and pass out. On the other hand, you might notice the listener getting distracted and looking around the room or glancing at his watch because he's feeling impatient and ready to see who else is out there.

Of course it varies from listener to listener, but the simple solution is to start at a moderate pace so that the listener can hear and understand your words, and not feel bored. Then as you get a feel for the other

person's voice speed, it is best to match their speed. Match it for a minute of so, and a mutual comfort will be established. In addition, matching voice speeds builds a faster and stronger connection, as well a sense of trust.

3. Be enthusiastic and use intonations.

Monotone is boring. Have you ever been in a classroom where you had to listen to a monotone (boring) teacher lecture every class and it took every last amount of energy to stay awake? Despite the fact that the instructor might be Einstein intelligent, this teacher could not draw the listeners in due to her lack of enthusiasm for the subject.

Even though the speaker may be intelligent and passionate about the subject, if what is going on in the inside doesn't show on the outside, listeners will not be entertained. If someone can bring a sharp level of enthusiasm and excitement to a topic being discussed, it brings a rainbow of colors to a person's words instead of just the ordinary black and white text. I am not saying you need to be enthusiastic the whole time, just sprinkle bits of enthusiasm throughout your story to keep the listener's entertained. If you want more of an explanation on how to be enthusiastic, or how to turn any "boring" story into an "amazing and unforgettable" one, take a look at Chapter 17.

Emotion is like the colors, and the black and white are the words. People want to feel emotion because that is the spice of life, and if you are able to give an emotional response, then what you are discussing will be remembered by your listeners.

Passion draws enthusiasm, which is why it is important to speak of something you are passionate about, and if you aren't passionate about the subject then find a smidge of something your passionate about when you speak, and focus on it because we often need reminders of our end-goals to stay motivated. For instance, if you're teaching a class on theatre arts, and you get to the subject of Shakespeare (which you detest due to the unusual word structure), yet you like the feather hats

that one of the characters wears in the play, then use that feather as a reminder, something that makes you smile. Or maybe you like the name "Puck" who is one of the main characters in Shakespeare's "A Midsummer Night's Dream" — so you keep a hockey puck or write down the name on a piece of paper next to you — and whenever you look at it you smile. It might feel funny, silly or strange at first, yet you will begin to see how fun, energizing, and beneficial this strategy is.

Another strategy to build enthusiasm is to reframe it, and attach it to the perspective of something you like — and not only like, but love! Something you have a burning desire for because passion brings enthusiasm, and enthusiasm brings excitement, which brings better listeners. Take a look at it from another perspective, the bigger picture to see who, or what else is there. For instance, maybe you aren't passionate about going to new places and meeting new people, however you love and have a burning desire to help others, which you use to stay excited.

Or maybe you aren't passionate about talking about roller coasters but your mom (who you dearly love) absolutely loves roller coasters, so to bring more enthusiasm you can try imagining how excited your mom would be on the roller coaster, with her hands in the sky waving holding a peace sign from above, or her in the back corner of your image flipping you the bird to add humor and excitement to the image. By doing this, you'll notice a shift in your voice when you are telling your story.

To begin with enthusiasm, start by putting an up and down tone in your speech, almost like your voice is on a baby rollercoaster. In the comfort of your own home, you can even act like you are an actor or singer getting ready for a performance. You can train your voice by utilizing "voice muscles" to expand the range of your voice. Here is a video for opening you're voice: https://www.youtube.com/watch?v=Q5hS7eukUbQ

All in all, enthusiasm is attractive, and will draw listeners in. If you want to be heard, and remembered, be enthusiastic. There are plenty of more examples at: https://www.youtube.com/results?search_query=how+to+sound+enthusiastic

4. Pro-noun-ci-ate Your Words

DO NOT MUMBLE. People do not like having to say, "What?" or "I'm sorry, could you repeat that?" or "Pardon?" or "Huh?" You get the point. And if the listener has to say it more than a few times, he or she might begin to feel slightly annoyed and thoughts will race across the listeners' mind thinking something is wrong with them, or question whether they should get their hearing checked, when the reality is that the speaker was mumbling. Therefore, you must enunciate your words audibly so that each syllable is crystal clear. If people keep saying "huh?" then it is time to think, "e-nun-ci-ate" because you are in the process of mumbling words.

Speaking in a room full of people means that there will be eyes glancing at you, judging you based on your appearance; there will be ears subtly listening to you, ready to criticize your words, tone of voice, accent, and speed (all of which influence your voice pronunciation), whether you like it or not. Be sure that you know how to pronounce every word, especially if you have an accent. You don't want someone thinking that you said, "Where's the douche?" when you really meant to say, "Where's the juice?" Or thinking you said, "french flies," when you really meant "french fries."

In the next chapter, I will cover pronunciation strategies so that you can get your voice how you want it, to boost your confidence when speaking to strangers.

5. Remember to turn up (or down) the volume.

I am not sexist to any degree. However, speaking from experience in starting thousands of small talk interactions, I've noticed that if men

have a slightly louder volume than the group when entering a conversation, he will be more accepted. Whereas, when he has a quieter voice, he probably won't even be seen or heard – unless he's extremely tall, or extremely handsome - because his presence is not strong enough. There is nothing significant that draws people to want to listen.

Whereas for females, it is more accepted if they have a slightly softer voice than the group when first approaching because a female presence will be more noticed than a man's. Men, by nature, will notice and women will be more accepting of females entering a conversation than a man. If she begins small talk with a louder voice, she is often seen as overly aggressive dominating figure, and will be less accepted (especially by other women).

6. Only use words you understand.

If you are unsure of a word's meaning, then do not use it. It's simple. If you say a word because you want to look smart, and don't understand the meaning or how to use it, it will backfire. People will get distracted from what you were talking about and often get stuck on that word thinking, "Why did she use that word? Or does she know what that word means? Or I need to "Google" the definition of that word because I swear it means something else." Make it easier for the listener to stay focused, attentive, and use words that you know.

Lastly, if you don't the meaning of a word, resist using it, stick it in the back of your mind, and "Google" the definition of it after the conversation.

Going back to the main topic – your voice. If you don't like something about your voice, it is up to you do something about it. You can always hire a voice coach or speech therapist, or if you want to save some cash, you can improve it yourself. Below is a strategy that has worked many people, including myself.

1. Record your voice

2. Listen to it and take note of what you want to change

3. Record your voice again

4. Listen again, and again take note of what you want to change

5. Take a break.

6. Repeat the process for 30 minutes in the morning, and 30 minutes at night for 30 days.

7. Look back in one month and see the incredible progress you've made. If it still isn't where you want it, continue the steps until it is.

You will begin to see a difference in the way people respond to you, and you'll feel much more confident when approaching strangers for small talk.

Chapter 6:
The 10 Powerful Beliefs That Will Let You Lead Any Conversation

It is one thing to *think* an interaction might be successful; and another thing to *believe* it will be successful. Therefore, here are 10 powerful beliefs and actions you can immediately implement to increase your confidence and success when making small talk.

The more you apply them to social situations, the more you will see how effective each of these beliefs can be. At first it may feel uncomfortable, but that is just part of the learning process and the more you do it, the more natural it will become.

Before entering a small talk situation, give yourself five minutes to read these beliefs to yourself. It has even more of an impact if you read them aloud to yourself, as well as truly feel and believe each of these to be true.

You can even put each of these beliefs in your Smart Phone or organizer as a reminder.

Belief 1: I feel awesome.

Take a few deep breaths, shake your body (do a little dance), and then relax. Next, think of a funny thought or something that makes you smile to get into a friendly, happy state of mind. For example, think of that time you saw the Chihuahua walking in the park with a cute pink little ballerina dress. Or that time you saw Uncle Joey get hit in the face with a whipped cream pie. Or that time when your brother tried to stuff as many grapes as possible behind his upper lip and tried to carry on a conversation – recollect something in your life that makes you smile.

Smile and feel into it for a few seconds before initiating small talk.

Belief 2: I am friendly, open-minded, and people want to meet me.

People want to talk to friendly and happy people, such as yourself. They are always more accepting of your initial approach if you can give off a relaxed, friendly, happy vibe.

One of the worst things to do when making small talk is to immediately pass judgment, or make assumptions without truly understanding the other person. For example:

- If a man has an unkempt and wrinkled shirt, don't automatically assume that he's sloppy and careless. Maybe he woke up late that morning, or was running late because he had to drop his kids off at school instead of his wife (who usually does) because she got sick, or any number of reasons. You don't know.

- Or just because a person is anoxerically-looking skinny, giving you an "ew" feeling when you first glance at her, that doesn't mean she has anorexia, maybe she has an overactive thyroid, which makes it extremely difficult to gain weight. She might be the most beautiful human being you've met all week.

- Or the man standing alone in the room, not engaging in conversation at first may in fact not have many conversation or social skills, but is the fastest typist you've ever seen, and is exactly the person you need for your business.

The point is that these people might be exactly who you are looking for, yet if judgment is passed too soon, you will never find out because they were already crossed off the list due to appearance.

You do not have to initiate conversation or spend heaps of time talking to everyone in sight, but everyone deserves an opportunity to be listened to and understood so that you can determine if you want him or her to be part of your life. However, after 5 minutes of tossing

words back and forth, you should know if this is a person you want to continue small talking with and possibly add to your life, or if you want to move on.

Eyes Don't Lie

Your eyes can be a weapon used for or against you. They give away your intention and mood. They reveal the truth behind your words. For example, love is an emotion that you can see through the eyes. When someone is in love with someone, you can see it in the eyes, and feel it. The same goes with when two people are attracted to each other, they can both feel it with the glistening of each others eyes, and then a flush of excitement runs through the body resulting in some form of a smile on the face.

The reality is that the expression in your eyes will give you away. They are like the headlights into peoples' emotions. The information given through the eyes brings a whole new level to relationships and understanding humans. For example, the eyes will show the excitement of seeing a friend for the first time in two years, the genuine love for a couple on their wedding day, the sexual sparks when someone is turned on, or embarrassment from speaking in front of a large crowd. You name it, and the eyes will show it. But, first you must be aware of it.

The interesting thing is that many people are not aware of how much the eyes give away. It is something that can be improved upon and after you master it, many people will even think you have special psychic or mind-reading abilities. For more information on what eyes are *really* saying, and how to detect lies based on eye movements, take a look at my self-titled book _The Power of NLP_.

Here is a game you can use to strengthen your emotional radar.

Emotion Reading Game

First, find someone you are comfortable with – possibly a good friend, spouse, or if you're feeling brave, go ahead and ask a stranger. Let's call

this "Emotion Guessing Game." It's fun and takes about 5 or 10 minutes (or as long as you feel comfortable).

First, sit about 4 feet across from the other person facing each other. Look into each others' eyes. One person will be the emotion guesser, and the other person will just sit there and either let his or her mind flow with thoughts, or think of specific emotions that ignite a variety of emotions. At first, you may notice emotions such as embarrassment, excitement, confusion, happiness, and nervousness – to name a few. Then the "emotion guesser" will try to read or feel how the other person is feeling.

As soon as you see a shift in the other person's eyes (due to an emotion-shift) be sure to call the emotion out. And of course, the more you practice, the better you will get.

Feeling Fearful to Feeling Excited

As previously mentioned, thoughts are the primary thing that can control emotions – similar to a roller coaster. Some peoples' roller coaster is like a death-defying coaster, which gives most people an eerie feeling in the stomach when glancing at it; while other people's roller coasters are like the kiddie roller coaster at a small amusement park.

Thoughts control emotions. Therefore it is possible to take a fearful emotion and transform it into an excited, happy emotion. For example, let's say you are in a quiet, non-social mood – similar to the one when you don't want to talk to anyone mainly because you are afraid you don't have anything to say, and after you approach someone there will be that awkward silence. This is only a thought you have that is creating fear inside your body.

Where is this fear? Is it in your stomach, your chest, your spine, your feet – where it is? Touch this area, and keep your hand on it. Next, think of a time when you met someone new because you were brave and initiated a conversation with him or her. It could be something as simple as saying "Hi," or "How are you?" and then something beautiful

formed between you two. For the purpose of this example, think of how it felt after you initiated the conversation and think of how exciting it felt once you connected with this special person. This is how relationships are formed, and everyone in the world has had success as well as failures when initiating small talk.

By tossing this fear out the window and transforming it into excitement simply with the power of thought, it will show all over your face and through your voice. Once you grasp this technique, it will show in your eyes, which have proven to be the gateway into a person's mind.

With small talk, it is important to transform all the signs of nervousness and fear of rejection into excitement and truly believe that people want to meet you, which should be no problem after implementing these beliefs. First impressions last and this simple technique of manifesting excitement out of fear is one that will turn first impressions into gold.

Eye Contact

We've all heard it in our 9th grade speech class when we had to give a presentation based on "Someone We Admire"; and we end up only receiving a B instead of an A because we weren't making eye contact despite the fact that we gave amazing examples that made the audience both smile and tear up out of happiness. The point being to look people directly into their eyes when communicating.

Naturally, some people feel uncomfortable making direct eye contact, especially when there is a superior/inferior mentality, or a strong sexual energy between two people. However, looking at people shows that you want to be trusted and that you are willing to hear what the other person wants to tell you. Even if a person isn't telling the truth, people will be more likely to believe it because of the eye contact. Although, with practice and knowing NLP techniques, there are simple ways to detect a lie. For more information, take a look at The Power of NLP, which explains Eye-Accessing Cues and much more to detect lies and

read body language.

Eye contact can be overbearing for some. If making eye contact is challenging for you, then instead of looking directly into the other persons' eyes (which can make people nervous and lose their train of thought), look at the middle point between their eyebrows; they won't even notice that you aren't looking directly in their eyes.

Another strategy is to imagine that there is a letter "T" on the face of the person. The horizontal bar on the letter is the forehead and the vertical line is the nose. Just scan the letter "T."

Interestingly enough, some people tend to look at a person's lips instead of the eyes when communicating. This actually gives off the impression that you are attracted to the other person, and that you may even want to kiss him or her. Therefore, if that is not your intention, be aware of what you are looking at when you talk to people, and adjust it accordingly.

Belief 3: I am confident, successful, and fun.

Body language is a vital aspect in communicating with other people. Body language is like the icing on the cake to give it the ultimate deliciousness. You can have cake without icing (or toppings), and few will remember it; just as you can speak incredible words of wisdom, however few will remember it without excellent body language.

For example, if you are saying an incredible statement about how you've discovered the cure for cancer but you have slumped shoulders, crossed arms, and your body is not facing the other person, it will likely come off as bullshit. Imagine if you had actually discovered the cure for cancer and you wanted to share it with a colleague. When speaking your shoulders were back (displaying confidence), arms at your sides (displaying that you're interested in sharing this information), and your body was facing them (to show that you know what you're talking about and that it's important). See the difference?

The funny thing is that most people know the importance of having great body language, yet 90% of people fail to maximize it – so be one of those 10% who maximize body language to be remembered.

Quick Tips For Body Language

I won't get into too much detail here about body language. However, there are some common mistakes that need to be touched on. You will see people "break" these simple body language rules whenever you are in a social setting. After learning them, you might even laugh to yourself when you see others "breaking these rules" and begin to notice patterns of why people do not easily get accepted when starting small-talk. Therefore, it is necessary to be aware of your body when making small talk to give off the impression you want.

- **Never cross your arms or clench your fists unless you're looking for a fight.** You will appear very closed off, and anti-social. Some may even think that you are annoyed and looking to fight. Instead, it's best to keep your arms at your side with open hands. The more open you are (with your arms, hands, and stance) the more approachable and confident you'll appear.

 Some people speak with their hands - especially the Italian culture – and that is great because it can add emphasis to what you are saying. However, be aware if it is distracting from your words. If you begin to notice the listener repetitively looking at your hands (instead of your eyes), it's probably a sign that your mighty hands are taking away from what you are saying.

- **Be genuine and real. For real.**

 A wise man by the name of Napoleon Hill stated, "It sometimes brings greater courage to be truthful, regardless of what those who do not understand may think or say." This rings true with many people, including myself as I have spoken with many people about the subject of understanding.

36

Each person on this planet has personality traits that far exceed those of others – we were all created differently. You may be great at empathizing and understanding what a person is going through, and can barely solve the math problem 13 X 9. This doesn't mean you're unintelligent. The reality is that one person may be extremely intelligent and completely unstoppable when it comes to communicating even at a level that some consider her a genius, and be embarrassingly lacking in math.

This is the beauty of being human. This is why we need each other to help one another out. It is impossible to be good at everything, and therefore allow what you are good at to glow within the darkness unless you bring it to the surface. At the same time, be vulnerable and realistic if you aren't good at something too. It will allow people to be more open, vulnerable, and get to the heart of what matters.

Be genuine and honest about your strengths and weaknesses. It is key to know yourself, accept it, and be real about who you are. Do not pretend that you know something which you actually don't know just to fit in. It is no problem if you don't know or don't understand something; simply ask for clarification so that everyone can be on the same page.

Socially Acceptable Guidelines:

- **The Greeting:** When approaching someone you are close with, you can sometimes disregard the greeting part. For someone you do not know, you must act formally and greet them with a "Hi," "Hey," "Good Morning," or something of that nature.

 Your greeting will depend on the person's background. For instance, if he is a boss of the company you are applying for, you should greet him formally and offer a handshake. Maintain appropriate actions for different circumstances. Another example is a meeting with a person who is Korean. The way of

respecting other people is done by bowing 90 degrees. You could adjust your greeting with a bow since you are respecting his culture. Be prepared to adjust your greeting for the culture and type of gathering.

- **Body Direct:** Face your body almost directly parallel to the person you are talking to and do not look around, at your watch, or cell phone.

- **Straight In The Eyes:** Look people straight in their eyes. This is to show you are telling the truth and upholding honor. Even though other people sometimes divert their eyes when you make eye contact, because eye contact can bring out shyness or an uncomfortable feeling; also staring at someone for lengthy periods of time can be considered "rude" so there is a fine line between looking at someone too long and not long enough, which will come with practice. Be aware of your eyes and see what works for you.

- **Open-up:** Keep an open body language. Keep your arms at your sides (and not stiff, but relaxed) because you will appear more confident, and if your body language is displaying confidence then others will treat you with better which will naturally cause you to be more confident.

If you are holding a drink, be sure to keep it at your side and not hold it across your chest because that is a barrier between you and the other person. You want to be able to connect (or feel if there's a connection) between you and the other person as quickly and effectively as possible to decide if you want to keep talking to this individual. Therefore, keep it chest to chest or in other words, just keep your arms at your sides.

- **Recognize Non-Verbals:**

 Over time, you will be able to recognize and know how to respond based on the other person's reactions. For instance, you'll be able to recognize when a person is using body language to state that they are uncomfortable talking about what your cat brought to your front door last night; or disinterested in the fact that you got drunk at a bar last night. The listener will either consciously or subconsciously turn their body away from you, or get distracted and start looking at the cell phone or glancing at their watch to subtly tell you, "If you don't change the subject fast, I'm out of here!" After recognizing this, you can choose your next statements wisely to either continue the current conversation or shift to another topic.

Belief 4: I am in the <u>present moment.</u>

It is just you and the person you chose to talk to. Create that world. Imagine a bubble around you and the other person you chose to talk to. The surrounding people and external noises *do not exist.* This belief is the gateway to make an incredible first impression and give the person the honor of feeling *heard.*

Everyone loves to feel heard and listened to. By showing that you have the ability to listen, your value will automatically be raised in this person's eyes.

- **Concentrate on one task at a time.**

 Not everyone is good at multitasking. When you try to do things at the same time, your attention will be divided. If you are talking to someone, then you might not hear some important if you are looking at your cell phone or thinking about drama that happened at work.

When conversing, whether it is on the phone or in person, the person in front of you deserves to have your full attention or else you are both wasting each other's time. Therefore, avoid looking at your phone to check a text or email, or accept a call. The mobile device can wait. Also, resist checking your watch (even if it's out of habit) because each of these display that you have more important things to do then interact with the human in front of your face.

As mentioned previously, this person will appreciate that you made the person feel special and important by completely listening. Interestingly enough this will make each conversation better because you will have a clear understanding of whether or not you want to add this person to your life.

Belief 5: I am positive and exert positive energy.

- People want to talk to people who make them feel good. Keeping a positive state of mind is a powerful strategy for creating small talk. If you are in a bad or negative mood, consider postponing small talk for a few hours until you are feeling in a better mood. If you are noticing your mood and thoughts tend to be negative, I suggest taking a look at _Positivity_, which will give you simple strategies to be in a good mood everyday.

Bring your topics of conversation in a light, blissful and positive manner, pressure free. Instead of saying _cannot_, use _can_. Instead of saying _bad_, say _not good_; instead of saying _hate_, say _didn't like_. Instead of saying ugly, say not pretty (or not good-looking). You get the point. If you keep saying negative things, the person will be turned off and leave (or use distractions to leave – such as cell phone, bathroom, or looking around the room). It is the words you use that create internal dialogue for yourself that directly affects the way you feel about yourself and the world around you.

Even if the person isn't nice to you, it's no big deal because 99% of the time it has nothing to do with you, so remain unaffected. Maybe the person you started talking to was having a rough morning after being chased by a dog and darting off in his car to get away only to find out that his tire was flat causing him to be an hour late to work and a harsh scolding by his boss. This may be a little extreme, but who knows, right? The point is to stay nice and pleasant until the conversation ends.

In uncomfortable situations, it is best to use negative body language to get out of a conversation. For example, turn your body so it is not directly facing the other person. Glance at your watch and say, "I apologize, but I need to go to _____(any place – the bathroom, a meeting, an appointment). It was nice to meet you."

Belief 6: I know what to say and when to say it.

The Top Conversation Topics of All Time

When talking to someone you do not know personally, you must know the topics that always work in a conversation. So, even if you don't know anything about the person, you can still wedge your way in and begin a successful conversation. Here are the ten conversation topics that always work:

1. **Psychology**

 The fascinating subject of the human mind that revolves around theories or reasons behind the way we as humans, are programmed to think. We are all eager to know ourselves and other people better. It brings a level of camaraderie and understanding between people and cultures. If you are a naturally curious person and enjoy psychology, gather up a few curious questions and program them in your mind to ask in small talk situations. If you want a list of excellent questions, take a look at 150 Powerful Questions by Tim Hansen.

41

2. Traveling

Many people love to travel and most people enjoy hearing stories about peoples' travelling adventures. Think of the last few times you've traveled, where it was, who was there, and one or two specific scenarios that happened during this adventure. If you don't already have a travelling story, try creating one with the 10 Steps in Chapter 17 because travelling stories are great to have in your back-pocket and can tell a lot about your awesome personality in a matter on one or two minutes.

3. Movies

Most people have watched a movie, except for those who live in a monastery. This is a very broad topic. There are a lot of great movies from all over the world. Talking about your favorite movie can lead to a topic about the characters and setting of the film, or how you can relate your own life to scenes in the movie. It is an excellent topic for building rapport and a feeling of connection when you've both seen the same movie and you both can recall lines and/or scenes in the film.

4. Sex (Gender)

Men and women will always be interested in talking about their similarities and differences. Some examples of things that you can ask to spark conversation are:

- "What's the best way to know if someone is interested in me?"

- "Who do you think is funnier – men or women – why?",

- "What's the best way to approach a beautiful woman?"

- "Is it socially acceptable for a woman to approach a man she's attracted to?"

- "How long should I wait to call a woman after she's given me her phone number?"

These are examples of what could be said. I suggest creating questions on your own that you genuinely want to know the answer to, and have fun with it.

Of course, as mentioned earlier, you always want to start out with a pre-opener such as a "Hey!" or "Hi."

5. Hobby

All people have a wide scope of hobbies and people enjoy talking about what they love. For example, biking, swimming, walking, reading, yoga, sports, etc.; and if you have a similar interest it is one of the strongest ways to connect and build a friendship. Even if you are simply curious about a person's hobby and want to listen to what she is saying, it can branch into many other amazing conversations.

This is one of the most common topics you can ask when you are just starting to know a person. This is a perfect topic for you to discover something new about him. Simply ask, "What do you do for fun?" Then you can ask for recommendations or opinions, which most people will happily offer.

You could talk about the places you prefer to go when you have free time. For instance: bars, restaurants, coffee shops, clubs, inns, etc. You could also suggest some place to her. Maybe, you want to ask her for another get together at your favorite place.

6. Food

Everyone has that certain food that they absolutely love – that food that makes a persons' mouth water when they begin imagining the look and taste, and even texture as they take that

first bite. This is a great topic surrounding recommendations such as: "What's the best pizza place around here?" "Do you know any good seafood places around here?" or "Do you have any recommendations for a good Italian restaurant?" or "Have you tried the new Sushi Restaurant on 6th Street?"

7. Career

This is a good topic which will identify what someone is passionate about. Questions surrounding this will allow you to understand why a person chose a particular career, or what motivates them to work — is it to pay the bills, for personal satisfaction, because they love it, or because they love to help people? It's fun to learn about people and what drives people to get into particular careers. I like to ask, "I'm curious about you and your career. What made you want to be a _____?"

8. Sports

Even though you may not even be a sports fan, having a basic knowledge of sports and trending sporting teams, players, and events will take you a long way (especially with men). Sports are one of the easiest ways to have a small talk conversation and build a connection at rapid speed. Just make sure you know what you're talking about. All it takes is 5 to 10 minutes a day, reading some sports news, and you'll be up-to-date, ready to engage in sport conversations.

9. News

It is good to stay informed with what is going on in the world, as it is a great conversation topic, especially because a good amount of the population keeps up with the news.

You might start a conversation like, "Did you hear about.....?" "Can you believe that happened?" or "What do you think about?"

Belief 7: I genuinely like people and believe that everyone has good intentions.

This belief brings a feeling of peace and ease to conversations. The pressure drops a level or two knowing the person in front of you isn't out to get you, out to embarrass you, or reject you. If for example, you go up to someone and you get shut down for some reason, then it's your responsibility to look at the situation and determine what went wrong. If you get shut down more often than not, I suggest reviewing the sections on body language and conversational openers. Once you understand and can implement the strategies throughout this book, you should be able to have a 95-99% success rate for starting conversations.

People have good intentions. Just because you perceive something as an insult, doesn't mean the other person was intentionally trying to hurt you. If it is hurtful, it is usually about the other person and usually based on a lack of understanding. People will bring others down based on their own insecurities to make themselves feel temporarily better, as that is the only way they know and understand how to feel better. Therefore, it was good for the other person because it made them feel good. This is a much deeper topic and I go into much more detail in The Power of NLP, which covers Neuroliguistic Programming and how to gain power over thoughts.

Belief 8: I can relate to anybody, and everybody

Everybody can relate to everyone in some way. Comfort can be built faster with genuine commonalities. I say genuine because they need to be honest common interests or else it will come back to bite you when the person discovers the you were being dishonest just to establish a connection.

You do not have to both be ardent fans of the band Grateful Dead to establish common ground. Stating a relevant topic that both of you had experienced can start a small talk. For instance, if there were a

45

hurricane recently, you could discuss how disastrous the calamity was. You should establish a connection between you and the other person.

After answering questions, it is better to let the other person speak. Do not worry if there is a long pause during the conversation. Once you begin asking questions again be sure they are relevant questions. This will enable both of you to be on the same page. Of course, once a topic dies out, then switch to another one (or even jump from thread to thread – or topic to topic – which tends to keep conversations more exciting).

There are hundreds of conversation topics to choose from. Remember that the solution to cure a dull conversation is to start a new topic. Simply be aware of the galore of topics you can talk about and be able to draw it up and shoot at the right time.

Belief 9: I am my best self

Let's face it. You are who you are. I am who I am. The person in front of you is who he or she is. We can't be someone else so you might as well be your best self. Show your vulnerabilities and be human. We all feel a wide range of emotions, from fear to excitement – and what makes us different is the amount we feel those emotions, the intensity of them, and the experiences that trigger those emotions. For example, the thought of small talk makes some people cringe and want to curl up into a ball and hide, whereas other people get small doses of adrenaline rush and are excited to meet the next new face.

That being said, be open and accepting of who *you* are. If you are one of those people who are totally afraid of small talk, that is great because there are a million other people out there who feel the same way. By showing your vulnerability and willingness to talk about who you are and your personality traits, others will be more willing to open up to you. They may be empathetic with you or feel totally the same way and you will immediately have something in common, which will make your connection even stronger.

Belief 10: I will decide whether this is a person I want to add to my life.

Let's say you entered a local coffee shop and spotted someone you found attractive, so naturally you want to talk to this person to see what she is about after reading "*Do* Talk To Strangers."

You opened the conversation with a question that required her advice. "I need your opinion really quick. I'm supposed to be heading up to my cousins tonight but I don't want to have to work with the L.A. traffic, so I was thinking of heading up there tomorrow morning instead. I just hope she didn't make plans for us tonight. What would you do?" This is great because people like to give advice and offer their opinion.

In addition, the advice she offered was helpful and made you feel like loads of weight was lifted off your shoulders because you got clear on the best decision for you. Then you transitioned into a light hearted conversation about ice cream because you saw that someone was eating some ice cold creamy ice cream outside which sounded perfect for the hot summer days in Fresno. A period of 5 minutes passes by and you are still all eyes and ears in the conversation. You feel the connection, and decide that this is a person you'd like to add to your life.

Your mind suddenly switches from the present moment to worrying about the future and how you can get her phone number but want it to feel natural. You don't want to miss this opportunity because you never know what this future relationship could lead to. You suddenly remember reading the "*Do* Talk To Strangers" and know the best ways to ask for a phone number and get it.

- "Hey, let me get your phone number. We should totally hang out." (hand her or him your phone so they can enter their phone number)

- "Hey I know we would have a lot of fun together. We should grab some ice cream some time. Let me get your phone number. (hand her your phone)"

- "Hey we should get together and go skiing (or any other activity from your conversation). I need a new skiing buddy. What's your phone number?"

If you build and feel the connection, all you have to do is ask and you will get the phone number. Although there are exceptions such as: if he has a girlfriend, or you came on too strong (for both men and women) without building a strong enough connection first. Once you feel the connecting point, then it's up to decide if this person you want to invite into your life.

On the other hand, say you were chatting with a woman and learned that she hates dogs, and you love dogs. You might ask her one more question to see if she can gain some points after the points she lost from "hating dogs." So you ask, "Where would you rather travel to – San Francisco or San Diego? She answers San Francisco, and she doesn't just leave it at that. She goes on to state how much she detests San Diego and it's "laid-back beach/surf" lifestyle. You love San Diego and are beginning to feel bits of confusion and anger in your body now for how much she doesn't like it. You decide that this is a red flag and this is not a person that you want to add to your life.

All you have to do is say, "Hey, I've got to run. It was nice to meet you and it was nice to chat with you." That way you show that you appreciate the time you spent together and for being a friendly human being who was receptive to your opening the conversation. Then, just continue on with your life as you are being selective with whom you want in your life.

This example was more of a qualification for dating scenario. However, you can use these same strategies anywhere, whether it be in a grocery store, at a business meeting, or a networking event to make friends and

build relationships. The next chapter will give a list of locations to meet people to begin forming romantic-relationships, friendships, as well as business and networking purposes.

Belief 11: I will remember names and important details about my conversation.

How to Effectively Remember Names

One of the biggest hurdles when meeting new people is the wonderful part where you have to remember a name... "I think it started with a G. Was it Gary? George? Geronimo? Ahhhh." Follow the strategies and this will not be a problem ever again.

The task of recalling names is not easy, unless you know how to do it. If you can't remember the names all of the time, then you should consider improving your listening skills in which I highly recommend a book titled <u>People Skills by Robert Bolton</u>, which improved my listening skills; as well as improve your ability to being in the present moment. In addition, forgetting names might occur because you are shy, bored, or anxious about the person you are talking to; however improving your listening skills and ability to be in the present moment should be your first steps to improving name recall.

Let's first talk about reasons why you'd want to remember someone's name so that way it might ignite a little fire so that you can feel the importance of name recall.

- Remembering a person's name is one aspect you need to make friends with them.

- It is important because it is a form of acknowledgement, which will allow the other person to feel valued and special.

- Recalling someone's name shows that you find your relationship meaningful.

- Remembering one's name is a sign of being modest and considerate.

- Imaging how unimportant and insignificant you feel when other people forget your name.

Again, poor listening skills are the most common reason for forgetting names. It often results from not paying enough attention to the person speaking. All you need to do is to give your full attention to the speaker and be in the present moment. If the reason why you can't concentrate is thinking of what to say to that person, then I would recommend looking at the Conversation Starters in Chapter 11, or use some of the 150 Powerful Questions from Tim Hansen's _The Coaching Questions Handbook_.

The best thing to do is memorize or internalize a few lines that you come up with based around your personality and interests. This way you can fire off those lines anytime they can contribute to a conversation. Once they are internalized they will become part of your repertoire of communication skills that will come out naturally without much thought.

If you don't hear someone's name, simply ask again. No big deal. Some people are embarrassed to ask again for someone's name because they don't want to make any mistakes. Was it really a mistake if you didn't hear the person due to their soft voice, a slight accent, or some noise from a woman in the background shuffling to gather some notes she'd taken on how to tell an unforgettable story? No. So just ask again and repeat their name back to them for clarity, and so that you can lock the name in and match it with this persons' face. Here are a few examples of things you can do for name recall:

1. Repetition is one way to help you remember names. A helpful strategy is to say, "Nice to meet you, John." Give the person a smile to show that you are glad to meet him. During the conversation, repeat the name a couple of times. Like, "Have

you tried the new Italian restraunt on 32nd St., John?" Also, you can perform mental repetition to remember the name more quickly. However again, don't get consumed with repeating the name silently in your head because you will miss out on the conversation.

2. Relate the person's name with an object or an animal.

- Select an animal or an object that has the same letter with the name of the person. (E.g. "Jen- Jet")'

- You can associate it with a word of the same rhyme. E.g. "Kitty - Pretty"

- Relate the name with words with having a similar meaning. E.g. "Mike - Mic"

- Think of a word which is similar in sound. E.g. "Paul - poll"

- Replace the words to remind you of a famous person. E.g. "Miley Fross – Miley Cyrus"

3. See every detail of the person's face.

Remembering a person's name also includes remembering a unique feature in his face so that when you see him for the second time, you could recognize the person easily. Find a unique thing you can remember quickly. For instance, you can put it in your memory that he has a narrow forehead, long hair, short eyebrows, small eyes, a white complexion, and many more.

For example: "Henry with curly hair," or "Sheryl with a big mouth."

4. Jot down important details

People tend to forget things after a few hours, and even a few minutes. If you have a piece of paper, napkin, or cell phone with you, then after the conversation you can jot down the important information so that you will have it the next time you two sit down for a chat.

After the conversation, take a small note (on paper or in your phone) of the person's name, and a few unique things about them. Write their names and characteristics so that you can visualize them. Write it immediately after you finish up your conversation with that person. You can also add the place, time, date and event where you met the person.

For instance, "John – gray hair, big glasses, likes golf, started engineering company 20 years ago and wants to sell company. Met at Sally's Coffee House." Use this as a reference, and if you review it later that night, you will be much more likely to remember his name next time you see him.

It will be a very helpful reference point for starting and opening conversation topics the next time you talk on the phone or sit down in person. The person will actually be amazed at what an excellent memory (and listening skills) you have – it is up to you whether or not you want to share your secret.

A person's memory has only limited capacity. You might forget things if you don't take notes, therefore I encourage you to get in the habit of taking only a few minutes after each conversation to jot down the important points. You'll be amazed at how much of a difference this little strategy will make in your name recall

Chapter 7:
More Questions To Ask & Topics To Avoid

Everybody wants to have an interesting personality that separates you from the rest of the crowd. To do this, the first thing you need to be interested and engaged in the conversation as well. Some things you must do for being a good conversationalist is to feed the other person with appetizing questions to get him talking, be an above-average listener, and be able to ask follow-up questions that are related to the topic. Then, you must be able to open up a topic that gets a person's juices flowing. However, keep most of your questions open-ended so that it allows for natural conversation to occur.

Here are some examples of juicy and thought-provoking open-ended questions:

- What do you want in life?

- What is your purpose?

- What do you want more of in your life?

- What does fun mean to you? What else?

- Is money or job satisfaction more important to you? How come?

- How do you believe that money and career are related? How does that apply to your life?

- What is holding you back from living your dream?

For more questions like these, take a look at Tim Hansen's *The Coaching Questions Handbook*.

The Awkward Moment Solutions

When talking to someone you do not know, it is common to have an awkward moment of silence or two. To fill the space, and prevent the person from awkwardly saying, "Whelp. See ya later," you can use one of these strategies.

1. Environment: Use the setting to revive the discussion. For instance, "This place has a cool ambiance. It's like we're in Paris. What do you think of it?" or "That is very unique art on the wall. Are you into art?" The point is, if you are feeling at a loss for words, look around your environment and use it to reignite the conversation.

2. Compliments: People love compliments. Take the opportunity to compliment the person you are talking to. I am not talking about complimenting the person on their looks; I am talking about complimenting him on his personality, or things you've noticed during your conversation. The only warning is that it may create a temporary awkwardness or silence while the person accepts the compliment, which may feel strange for some, as many people do not know how to receive compliments. The best way to accept a compliment is to smile and say "thank you" to prevent awkwardness,

I like to use "4 seconds of silence," where I say a compliment such as "I really admire that you would practically give everything you had at the time to help a homeless man on the street. It shows your love for helping people." Wait 4 seconds for the compliment to register and for him or her to accept it, then if there is still silence, begin another conversation topic.

Topics To Avoid In Small-Talk

After knowing what topics are best for small talk, it is important to know the topics which must be avoided because it might cause bad blood and put the conversation to an end. Some of these topics will sound obvious, yet they must be touched on. Here are the ten topics that one must avoid in a conversation.

1. Politics

People have different points of view when it comes to politics. Maybe, you are talking to someone who has been a proud supporter of the politician you despise. Avoid talking about this topic if you do not want the two of you end up debating about politicians.

2. Financial Aspect

It is ill-mannered to ask about someone's financial status and assets. His career or business, but never ask about the monetary value behind it. Most people will feel that they being stepped on.

3. Religion

This is a very sensitive topic. People have different beliefs about the Almighty. If you engage with this topic, then you might offend the person you are talking to.

4. Age

It is usually considered rude if you ask for someone's' age — especially a woman. Although, most people will reveal their age if asked, it is not recommended to do, especially when you first meet someone.

Anyway, what is the point of asking anyone's age anyway? It is not a big deal.

What matters is how you feel inside. Do you feel 50, or 25? If you feel 50, what are you going to do to make yourself feel younger?

5. Gossiping

Gossiping will not win you friends. In fact, gossiping may earn you some enemies. If, for instance, you hear something from co-worker Betty about how John is stealing money from the business account, it's best to not repeat anything you hear because John did not tell you that, Betty did.

Maybe co-worker John knows co-worker Betty and wants to tell her all the bad things that were said about her. He might know the person in your gossip personally. Avoid talking behind people's back.

6. Avoid Offensive Jokes

Avoid offensive jokes (sarcasm that makes someone want to hide from the world for at least a few days), even if you are just trying to add a bit of humor to a situation, avoid it because offensive jokes weigh much heavier if a person does not know you. It can immediately plummet or destroy their first impression of you so that you will be remembered as "the jackass who makes offensive jokes, because people will talk.

If you are insulting to others, you will be seen as negative, and most people do their best to avoid negative people. If you are looking for strategies to develop a positive thought process, take a look at my self-title book, _Positivity_.

Sarcasm is okay if you already know that your listeners enjoy those type of jokes, such as friends and family. Therefore, keep it as a rule to not use sarcastic, potentially offensive jokes. You are not hired to be the comedian and you don't know how the person will respond.

7. Limit Narrow Subject Matter

It's simple, especially after reading Chapter 17, to tell an interesting story that will grab the listener's attention. However, if you decide to use narrow subject matter, such as a novel that only you have read, then make your story compelling, entertaining, and interesting – or you will immediately lose the listener's attention.

Life is the grandest experience and ultimate experiment – and it is your choice on which perspective you choose to approach life. The way I see small talk is similar to opening a new package under the Christmas tree – you have an idea of what will happen (or what it is), yet you aren't 100% sure of what it is or how they will respond until you rip open the package to see what's inside. If you look at life from this perspective, you will always come out on top of the pack because even if you fail, you can applaud yourself because you experimented to see what was possible. Be excited because you never know what adventure your next conversation will bring you.

Small talk is a process that will gain you friends, business partners, networking opportunities, potential romantic pursuits, and the opportunity to advance and become who you desire to be in the world. As the saying goes, "it's not what you know, it's who you know," so get out there and small talk.

SECTION II: MEANINGFUL CONVERSATIONS

You glimpse across the room and notice the most beautiful, sexy woman you've ever seen talking to another man whose just introduced himself. You suddenly feel this flush of defeat run through your body as you think to yourself, "If only I could be that guy."

Then it hits you…It's not the *guy* you want to be, but it's the ability to start a conversation and immediately connect with the other person so that it feels like you've known each other for years.

You glance over again and notice that she begins laughing at something the man just said and unconsciously begins playing with her hair. It's obvious she is attracted to him. You turn your head away because you don't want to give off the impression that your staring, even though all you want to do is *look*; and not only look at her, but look and *hear* what the man is saying, what his body movements are communicating, and how you can replicate the smooth confidence.

This book covers the juicy stuff, the stuff that gives you the ability to *choose* who you want to be part of your life. You will soon be so confident and comfortable when talking to strangers so that it feels like 2nd nature to you. You will have the ability to immediately connect and feel like you've known each other for years.

You will find out about *things to talk about* and ways to get to the small talk – and past the small talk to a level of intimacy where you are *really* getting to know each other, knowing who that person *really* is – the stuff that matters. It all begins with the way you start a conversation. Some might call it conversational intelligence – which is the ability to begin and form any type of relationship you desire – whether it is for business, friendship, sex or romance.

Relationships *are* the best part of life. Most people form relationships by meeting people through mutual friends, co-workers, or classmates.

This book skips over all that – the easy, less adrenaline pumping stuff. You may be thinking that this is for the "socially advanced" and I'm here to tell you that it's not. Although some of the aspects discussed will push you to the edge of your limits, I wrote it specifically for the people who are *not* the most socially savvy.

You'll soon be able to enjoy conversations and use them to boost your happiness, and bring more richness to your life.

You're in for adventure because if you continue to follow the steps provided in this book and turn it into a habit, then you will be kissing your old shy, lonely-self goodbye! It will take practice, and as long as you are willing to put in the time and implement what you're about to read, you *will* significantly boost your conversational skills and know how to start a conversation with anyone.

Chapter 8:
Talk To Strangers

What is the hardest part of 99% of conversations IN THE WORLD?

It is the fear of being rejected and feeling uncomfortable when you open your mouth. This feeling is one we usually try to avoid at all costs because we doubt out abilities. Instead we glance at our phones to see if we have a new text or the news updates on Facebook, and talk ourselves out of engaging in conversation to resist the *possibility* of being rejected. At the same time, we'd enjoy if someone else did the dirty work and just approached us.

It's the thought of knowing "what to say" that is most challenging, so again we disregard our curiosity and thoughts of "I wonder what that person is like, how her voice sounds, how soft her skin is, or if she is as intelligent as she looks."

The Opener

What if you could say anything to the other person? Anything from "Yabbadabbadoo!" (in a Flintstone voice), to "Hi. You're gorgeous!" to "Hi, do you know how many stars are in the galaxy?" and have the other person respond with a genuine smile and be happy you have entered their world! The beauty of conversation openers is that you can say each of these – as I've experimented with hundreds of different openers.

It doesn't matter *what* you say, more importantly it's about your *energy* and ability to match (or have a slightly higher energy level) than the person you have chosen to interact with. You are bringing a whole new realm of possibilities to this person's world similar to when a new person enters a room and you can feel the energy shift. Who are you? What do you want? What can you bring me?

Once you say, "hi" or "hey", the conversation has officially begun. If you skip this step and go straight to the question or statement, you automatically lose points because you've startled him or her. For one, *you're a stranger* to them and you have no idea what path their mind was on before you said you're *brilliant opener*. Here's a quick solution - always acknowledge him or her with a "Hi" or "Hey", and the defense mechanism will automatically be lowered. I'll go into more details about that in Chapter 2. But, first let's take it a step back, and get your mind comfortable with talking to strangers.

Your approach is only half the battle. The other part is up to him or her. If you do your part well, then you can significantly boost the chances of them responding favorably.

It's human nature – We, as humans DO NOT want to feel rejected because then we will feel as small as a peanut. Our ego will be shattered. Our self-confidence will be shot down to the ground. We will begin to question what we did wrong or what is wrong with us.

If you *do* get rejected – keep this perspective in mind: *It probably wasn't you.* Maybe the blonde haired woman carrying a black Marc Jacobs handbag with a funny-looking Chihuahua popping it's head out that you'd just approached was having THE WORST DAY OF HER LIFE. Maybe her cat named Frisky just died or she had a bird poop on her handbag at lunch, or she was still hung over from the red wine she drank last night.

Use Your Imagination To Build Comfort

Your tone of voice, body language, and the energy that you bring are the most important parts when starting a conversation. Each of these will determine how the other person responds to you whether it's a stranger or someone you've known for 10 years.

Think of how beneficial it would be to increase your chances of success with each person you approach. The secret formula that I'm about to show you is a proven-to-work method because I've used it for

over 5 years when approaching strangers in coffee shops and on the streets of San Francisco. It's worked at 100's of networking events in which I've met some of the most amazing individuals, and met people from all over the world.

Step 1: Take 10 to 60 seconds to prepare before walking over to the other person to significantly boost your chances of success. If you're in a setting where you feel comfortable closing your eyes, I recommend that. If your not, use your cell phone to glance at for 10 to 60 seconds while visualizing yourself in action. *(Keep in mind that you DO NOT want to look at the other person for more than a few seconds, because then you will likely begin to feel anxious and not want to approach.)*

Next, imagine or visualize yourself walking toward the other person, and see how the facial expression is of both yourself and the other person. Are you smiling or excited to meet the person? What is his or her face saying to you? If it's not how you want it, then erase that image and shift it to a desirable image – but start from the beginning again. Once it's the way you want it, you've completed the first step.

Chapter 9:
The Stuff That Comes Out Of Your Mouth

Communication is supposed to be as natural for humans as breathing air. After all, society and civilization CANNOT and WILL NOT function if people did not effectively communicate. From the first glance at a new stranger, to small talk with a waiter, to talking to the lady at the gas station pumping gas into the car next to you, you are always communicating.

But not everyone is gifted with smooth communication skills and emotional intelligence. Sure, a person can talk. He or she knows how to speak the language and how to read it, but communication goes far beyond speaking and reading. It is both a science and an art, with a lot of nuances in between.

How do you communicate with a stranger or a person you've never met - perhaps someone you're attracted to or fascinated with or someone you want to ask a favor from? This is where most people have challenges. The first few seconds are important, but not nearly as important as the first two minutes – in which you have the ability to hook, or grab the listeners' attention. In other words, if you totally blow the first few seconds, it's not a big deal because you have two minutes longer to make a great impression.

Have you ever had someone come up to you, start talking, and it sounded TERRIBLE? As you're about to run away from this guy because of his "awkward introduction", he says something that grabs your attention, such as "Can you believe he's slept with that many women?" Then your mind immediately shifts to "how many women did he sleep with?", and your curiosity is triggered.

If you totally mess up the first few seconds, you have two minutes to recover and connect with the other person. You may have had something planned to say that came out like a jumbled hairball. You may have approached and forgotten what to say, or you may have

approached the person without a "general purpose".

Have a Purpose or Goal

When I say purpose, it is an immediate reason to start communicating with someone. The purpose gives you a reason, which will, depending on how compelling it is, be the driver to get you into action. It's easier than you think because the driving purpose can be very general, such as "to meet someone new because I'm curious about people," although the more specific the purpose, the better.

Five of the most common reasons to meet people include:

- You want to connect with someone on an emotional, physical, and spiritual level

- You are physically attracted to someone and are curious to find out if there is chemistry between you two

- You are looking for a new friend whom you can do recreational activities with

- You want to find prospects whom you can do business with or exchange business contacts with

- You admire something about another person (intelligence, emotional intelligence, physical appearance, fame, etc.)

Here are some examples of reasons to strike up a conversation:

Why do you want to talk to the beautiful stranger sitting across the room from you?

- Maybe you're considering switching from a PC to a Mac laptop, and you are wondering how well she likes her Mac.

- Maybe you like his style and want to know where he shops because you're looking to upgrade your wardrobe.

- Maybe you are drawn to that person because she absolutely gorgeous and you know you will regret not talking to her

Why talk to your next-door neighbor checking his snail-mail?

- To build rapport with him so you can count on him if needed

- Because you were raised to be friendly and meet your neighbor

- To find out if he has children whom your little ones can potentially play with

Be Honest

Whatever your reason is for talking to someone, be sure you are "mostly" honest and genuine because people (especially females) can see through lies. They will sense it from a mile away and know if you're full of crap or not, based on how congruent your words are with your body language and tone of voice. She'll be able to sense if you just want to sleep with her, or if you are trying to sell her something, or if you're genuinely a friendly person just looking to meet people.

I say "mostly" because I believe that people in general, are mostly honest. An example from when I first started talking to strangers is my "watch opener". For instance, I spotted a man dressed in a business suit that looked like someone whom I wanted to potentially do business with. I opened with "Hey, do you happen to know what time it is?", despite the fact that I had a watch hidden underneath the sleeve of my long-sleeve polo shirt, and I had a cell phone which displays the time as well.

Be brutally honest and straight-forward. I am not talking about a negative, pessimistic, insulting or overly sexual version of brutally honest. If it is any of those four, then you need to reword your statement, or you're asking to be rejected. It can sometimes be beneficial to have an outsiders' perspective of whether a statement is appropriate or not. You can even ask someone in the room (other than

the person you're considering talking to) what they think about the statement you're about to say or how they think it will come across – which is another awesome conversation starter, and a good way to make friends.

When were talking about honesty, it's important to be honest with yourself, your feelings and emotions. If you are interested in someone, communicate it (and it doesn't have to be verbally, although it can be). Most of the time it will be non-verbal (strong eye-contact, touching on the shoulder or arm, asking curious questions); on the other hand, be brutally honest if you're *not* interested in someone. One of the worst feelings is being dragged along thinking someone is into you, when they really aren't. Therefore, communicate what you're looking for and what you want out of each relationship. A few examples include:

- Completely for intellectual stimulation

- A completely sexual relationship

- A long term partner

- A strong emotional connection

- Someone to relax and "shoot the shit" with – completely nonsexual

The truth is, learning how to converse with strangers is not really that easy. It takes practice and observation. The people who are good at it are the ones who have gained experience and who are keen observers.

It should be a fun experience. If you fall flat on your face and find yourself in an embarrassing position, just joke about it because in the big picture it is NO BIG DEAL. By laughing at yourself, you'll build your self-esteem and people will often empathize with you.

After all, there is nothing to be embarrassed about because the reality is that we all make mistakes, which ultimately make us better for our next approach. For one, you will become less affected by the "embarrassing statement"; For two, you can adjust it and fine-tune it for next time so that it comes off the way you want it until you get the response your looking for.

Smile

A smile is one of the simplest strategies to immediately raise the value of your first impression. It has alarmingly powerful effects on the world around you. Smiles can completely change the frequency of ones day - from shi**y to f****n great!

Sometimes you have to fake it until you make it – as the saying goes. This is true because faking a smile will take you much farther when it comes to initially meeting a stranger. You might even feel goofy or like you're not "being yourself", however the more you smile the more natural in will feel, and eventually if you do it enough, it will become a habit (which takes 30 days to form). People are usually more accepting of people who smile because it makes you look more fun, friendly, and easy to talk to.

Stay Positive

People are drawn to others with positive energy. Why? Naturally, people feel better around people who can see the good out of situations as opposed to the negative things. They bring comfort and optimism to situations.

There are two sides two every coin, just as there are two sides to every situation in life. Therefore, you have the option of *choosing* to see the negative or *choosing* to see the positives.

The first step in trying to get into a positive state of mind should be to smile and think of a funny thought. Another quick tip would be to change the word tone from a negative frame to a positive one. I go into

much more detail in my self-titled book, _Positivity_. A few examples include:

- Instead of saying, "That's an ugly shirt. Why are you wearing that?" Find one thing you like about it - maybe the color, maybe the way it fits on the person, maybe how pressed it is, maybe the texture. Then begin with that. You could say, "Cool shirt. What's that about?" The point being to find and focus on the positives, as opposed to the negatives of _any_ situation.

- Instead of saying, "This party sucks." You can say, "What do you think of this party?" It'll give the other person an opportunity to open up to you.

Step 2: Have a clear purpose in mind. Why do you want to talk to this person?

Step 3: Smile. Be happy with yourself - wherever you are. Think of something that makes you smile, or something funny that will put you into a happy state of mind.

Step 4: Always begin a conversation with "Hi," "Hey", or "Hello". This will lower the other person's protective shield.

Chapter 10:
The Golden Key To Overcome Anxiety

We get nervous or anxious when talking to new people. It is because people are generally uncomfortable with the unknown. You have no idea how they will respond to you.

However, I've learned through thousands of approaches, that there are three keys to overcoming anxiety and being completely comfortable with meeting strangers. Be in the present moment, use your intuition, and be curious. If you can have these three skills in the back of your mind at all times, you will be successful when talking to anyone.

How to be in the present moment

Take a few seconds, and relax. Watch your shoulders, straighten your posture press your back against the back of your chair. Listen to your breathing. This will allow you to be more in touch with your emotional states. It often takes practice, but it is a skill well worth learning. It's an awesome thing to notice which emotional state you're in, acknowledge it (either verbally or check-in with it) and either keep it or change it.

You can go from being *nervous* to *curious* in a matter of seconds. One strategy is to ask yourself "what is going on now?" What is your body saying? Then accept it and think of something that would make you curious. For example, why is the grass green? What nationality is that person? I wonder why Volkswagen's slogan is, "Think small." Often times I've noticed that curiosity can strike up a really good conversation if you actually say something like, "Wow, I'm not sure why but I'm actually really nervous around you." That also goes to being honest with yourself and your emotions.

In this example, when we take nervousness and acknowledge it or except responsibility for our emotions, then we can change our emotional states. From that point, it will be much easier to get into an emotional state of excitement after the emotion of nervousness has

been acknowledged and accepted. The worst thing you can do is deny the emotion because then it will keep coming back and will not leave.

I go into much more detail in my self-book titled <u>How To Live In The Present Moment,</u> which is filled with information similar to the previous paragraphs.

Intuition

This leads me to my next topic, which uses being in the present state of mind and being aware of your thoughts. Intuition locations vary from person-to-person. For some people it comes as a quick tingling in the stomach, or a flash of thoughts in your head that only last a few seconds, or like a quick wave of excitement racing up your spine. It is one of the most powerful conversation tools that can be developed and strengthened with practice. Skilled conversationalists know how to use their intuition to change the direction of the conversation, and keep it exciting.

Intuition is often considered a sixth sense, or just a feeling that you have about the future. Most of the time it is like a flash that only lasts for a few seconds and is quickly gone. Therefore, if you want to use your intuition or develop the skill for accuracy, it is important to be aware of it.

Intuition comes when you're truly listening. Listening at a level that is not just with words, but instead being in connection and truly understanding what the other person is really saying. It is kind of like looking for things that are behind the words and in between the words, the true meaning.

Intuition is a level of emotional intelligence, which is something that can be developed and strengthened as opposed to intelligence (IQ) – which is the ability and speed at which you learn something new – and it can be improved only slightly, if any. For more information on emotional intelligence, I highly recommend *<u>Emotional Intelligence</u>* by Daniel Robbins.

Curiosity

There is a certain sort of innocence that comes with curiosity. It's kind a like who would ever get mad at you if you just asked a question completely out of curiosity. If you're asking because you're completely curious, then no judgment will be passed - which is often the thing that people are afraid of when they are considering being open about a subject.

If you begin a statement saying, "I'm curious, (fill in with your question)", then the person will be more likely to openly share. When it's a tougher subject to speak about, speak from a place of curiosity and begin your statement with "I'm curious..." to lighten the mood. For instance, you can say:

- "I'm just curious, why did you choose to die your hair blue?" as opposed to "why is your hair blue?"

- "I'm curious, what made you want to respond the way you did?" as opposed to "why did you respond that way?"

Step 5: Practice being in the present moment, using intuition, and being curious when talking to strangers. These skill-sets usually take time to develop so the more you do it the faster and better you will get.

Chapter 11:
How To Start A Conversation With Anyone

So how exactly do you know the *right* thing to say?

There's not a magic thing you can say to immediately hook the person. Although there are things you can say that will stir more interest than other statements or questions. Just as there are things you *do not* want to say, as mentioned in the last chapter with pessimistic, judgmental, and negative statements because they will put the person on the defense.

Conversation Starters

Questions are always a good way to start a conversation since they spark interaction, automatically drawing in the other person in. Open-ended questions are best because they generate longer responses and give conversational threads to grasp on to. For instance you ask, "What was the best part of your day?" the person might say, "I got a mint chocolate chip ice cream from Baskin Robbins. It reminded me of when I was a kid and how I would go there every Sunday afternoon with my family." From this point, you have several conversational threads to grasp on to including:

- Mint chocolate chip ice cream

- Baskin Robbins

- Being a kid

- How you had family time on Sunday

- Your family

- How you haven't had ice-cream for months and you miss it

- And several others based on the persons tone of voice and

body language

The point being that open-ended questions are better for conversations than "yes" or a "no" questions. They require expanded answers or explanations.

The New "Why" Question

Generally you don't want to begin conversations with "*Why*" questions because, as mentioned before, it has a tendency to put him or her on the defense. It can sometimes come off as an insult or judgmental like you are trying to put them down. For example, if you said, "Why are you staring at your drink?" it has a type of energy. Whereas there are two types of strategies you can do if you want to ask a "Why" question.

- The first would be the curious statement: "I'm curious, why are you staring at your drink?"

- The second would be changing the "Why" to a "What made you want to" or "How come", such as "What makes you want to stare at your drink?" or "How come you're staring at your drink?"

- If you want to soften the statement, you can combine the two. For instance, "I'm curious, how come you're staring at your drink?"

Situational Openers For Women

If you spot a man who's watching the game, after an important play you can casually tell him, "You know they shouldn't have done that…" then stare straight at the game again. Make it casual. A lot of people make small talk with other people when they are collectively observing something.

If the person responds and gives you his opinion then it's an opening, an opportunity for you to engage him in small talk – related to the

game. If he just smiles or laughs, he might also agree with you but is not much of a talker or he's being polite but doesn't really want to talk. If he ignores you, then he's not interested.

Situational Openers For Men

If it's a woman and you're attracted to her, *be in the present moment* and *be curious* about what she's doing or what she's drinking.

Keep the conversation polite because women are wary of strangers talking to them. Keep it nice and friendly. Women don't want to be pulled into a conversation they don't want to have. If she replies then it's okay to talk to her. If she just smiles then move on and remember IT'S NO BIG DEAL or you can observe another thing in the environment and give it another shot.

Use "Psychic Abilities" To Make Predictions

This is always fun, and it's a good way to improve your "psychic abilities" or ability to read people based on the way they look. If you glance at someone, and immediately you think, "Oh that person looks like a teacher." Or "that person looks like they were in the military," or "that person looks like they are an actor"…tell them that. Test it out to see if you're right. Whether your right or wrong, it'll be fun, and you'll get better each time you do it. Most importantly, it is an excellent conversation starter.

Here are some examples:

1. You look like a world traveler. Which countries have you visited?

2. You look like a "name a drink (i.e. dirty blonde, sex on the beach)"

3. You look fun. I bet you're the type of person who…

4. You look just like my friend that I met while traveling through

South America. Are you from South America?

5. You look like a beach girl. Are you?

Compliments (only if you are genuine about it)

Compliments are great, and people love them! Although, generally speaking it is best to NOT compliment people on their physical features (unless you are completely genuine) because people will often see it as though you just want something from them – and it is often interpreted as you either to sell them something or have sex with them.

However, if that is your intention, go ahead and compliment them on their physical features (as long as you are genuine about it and mean what you say).

Here are some examples:

1. That's a cool hat. Where did you buy it?

2. I like your shoes. Where did you get them?

3. I like your necklace (or jewelry). Where did you get it?

4. I like your energy. You seem very fun and spontaneous (or something you sense about their energy).

5. You're absolutely gorgeous. What's your name?

Emotionally stimulating

We all love emotionally stimulating conversations. Ones that make us laugh so hard that it feels like we just completed an extreme abdominal workout; conversations that make us feel happy and smile; and conversations that get us excited about our future. Women are more likely to engage immediately in emotionally stimulating conversations than men, because by women, are usually more connected with their emotions.

Here are some examples:

1. When you're 95 years old, what do you want to say about your life?

2. What is your dream?

3. Would you describe yourself as more introverted or extroverted? How come?

4. If you were stranded on an island, what 3 things would you bring with you?

5. If you could travel anywhere in the world, where would you go?

Opinion Openers

We all have opinions and we enjoy sharing them. That is why opinion openers can be excellent conversation starters. Opinion Openers are always best when they are something you are genuinely curious about and want another persons' perspective.

Here are some examples:

1. What do you think of this restaurant?

2. Justin Bieber or Miley Cyrus?

3. What do you think of Harley Davidsons?

4. What do you think of people who drive Ferrari's?

5. What does happiness mean to you?

Relationship Questions

Men, and women especially enjoy giving relationship advice. We are all problem solvers and want to offer our perspectives and opinions to see if we can solve or alleviate a problem that someone is dealing with in a relationship. Similar to opinion openers, these are always better when

you ask about either a situation *you* are going through or a friend/colleague of yours is going through.

Instead of starting out with "I'm curious", you'll want to open with "Let me get your opinion really quick." This will immediately spark the person's interest and it is an easy way to jump into a relationship-type question.

<u>Here are some examples:</u>

1. A buddy of mine has been dating this girl for a few weeks and wants to ask her to be his girlfriend already. Is it too soon?

2. Who do you think is more sexual – men or women?

3. Would you be mad if a guy you were dating was also dating 2 other women?

4. If a guy were to pick-up on you, would you rather have it be in a bar, coffee shop, or online?

5. My friend recently got divorced. How long do you think he should wait before he starts dating again?

Curious Questions

1. What nationality are you?

2. Do you think giraffes or monkeys are smarter? Why?

3. Do you believe in horoscopes?

4. What's your all-time favorite movie? Why?

5. What's kind of music do you listen to?

Step 6: Choose a type of question that grabs your interest. Test it out and see what happens. Most importantly, have fun with it!

Chapter 12:
What Our Bodies Are *Really* Saying?

Talk is cheap. Actions speak louder than words. If you're going to talk to talk, you better walk the walk. Do you see a pattern here?

You can say one thing and do something completely different. People can talk all they want but if their actions are not congruent with their words, then their social value will crash into the ground and often they will not get a second chance because they will be perceived as a liar. That is, of course if the listener is keen enough to pick up on the incongruences. There are even times when we are unaware of our body movements, and they can work against us, even if we are telling the truth.

For instance, let's say you're at a networking event and meeting new faces. You begin talking about the loads of success you've had with your online business over the past year. However, your body language and facial expressions are screaming, "I'm not confident. I am hiding the *real* truth. I am nervous about something," you may come across as a liar, even if you're telling the truth.

If this happens, then the listeners' ears will shut off and they might start day dreaming about what they want for dinner or spot another person in the room that they want to talk to, completely ignoring what your saying. All at the same time, appearing like they are listening as they nod their heads and give the occasional "Yeah, or Uh huh." Therefore, to deter any thoughts that may distract the listener from what you're saying, it is a necessity to train your body and facial expressions to appear congruent with confident body language.

Here is the "Do and Don't" list of Body Language. These can be applied to meeting new people, dates, networking events, and social gatherings.

The Do's of Body Language

- Keep your hands at your sides (not in your pockets)

- Make direct eye contact

- If you have a drink, hold it at your waist (not your chest)

- Stand up straight, keep your shoulders and head back

- If sitting, lean forward because it will show that you're listening

- Open up your arms and body

- Face your partner

- Nod to show that you are listening and understand

- Ask questions to show that you are focused and listening

- Smile to give off a friendly appearance and so that people will be more likely to engage in conversation with you

- Mirror or match the person's body language (approximately 50% of the time) because it will create a new level of connecting with the listener

The Do Not's of Body Language (or things to do if you want an escape route)

- Do not cross your arms across your chest because you will appear closed off, annoyed and non receptive to what the other person is saying

- Do not fidget because you'll appear nervous and uncomfortable

- Do not bite your nails because it'll appear as if you're nervous about something

- Do not point at another person because you'll appear socially incompetent.

- Do not rub or touch body parts because that is a sign of uneasiness

- Do not play with jewelry because it will make you look nervous and could be distracting for the listener

- Do not tap a pencil or pen on a table or other hard surfaces because it is distracting

- Do not constantly glance away from the person who is speaking because it'll appear that you are not interested or are not listening

Be aware of your body language. It's may be a sign to yourself that you're feeling uncomfortable, nervous, or have something (or someone else) is on your mind. At the same time, be aware of the other persons' body movements in order to determine how you should shift the conversation.

As mentioned before, if you'd like more information on understanding body language, take a look at _The Power of NLP,_ where I go into specific detail and ways to determine what a person is thinking based on their eye movements and body language.

The Listener's Body Language

A persons' body language often says more than words. After all, why wouldn't you want know if a person is uncomfortable talking about butterflies and roses because they remind her of an ex; or talking about sports when the guy next to you hardly knows the difference between the Chicago Bulls and Chicago Bears?

Body language can show whether the listener is happy or sad, uncomfortable or guarded, or what it is that he or she is *really* saying. It can say things about how they are feeling at a certain point without them even realizing it.

Recognizing body language is important to learn if you want to become a good communicator. It will help you understand if your listener is enjoying your conversation or if you've made him uncomfortable. These cues will help you know when to change the topic of your conversation or when to stop talking. It will also tell you if it's the right time to give an *important* announcement or news.

Understanding body language is especially important when starting a conversation with strangers.

- Is it the right time to talk to talk?

- Does that person look relaxed?

- Are his arms crossed in front of his body?

- Does that say the person is open to conversation or not?

Observe

You must learn to be observant. Great communicators are people who truly watch and listen to others. They study and learn about effective communication through their experiences.

Body language can either be positive or negative. Positive movements show a relaxed individual, someone that appears to be comfortable with you. It includes moving towards or leaning closer to you. For example, if you are seated in a sofa and your companion is seated somewhat facing you and leaned towards your side then he or she finds you interesting.

If he or she leans away from you with his or her body faced elsewhere then it is likely they he or she does not want to talk to you or does not enjoy the subject you are talking about.

Our hands also say a lot about our disposition. If the arms of the person you're talking to are relaxed, then that's a positive sign. But if they are crossed then it could mean that he is not into the conversation.

Perhaps the most popular sign is eye contact. We often read in books or see in movies that a person who cannot maintain eye contact could be lying. Or it could mean that he or she is hiding something from you. Meanwhile, maintaining eye contact means attentiveness in the conversation and honesty.

Scratching or rubbing the nose or the back of the neck may also be a distraction. The person is trying to distract you from what he or she is saying. It could be because they are lying or just simply embarrassed.

It is important to remember that body language, like the written and spoken word relies on context. You must observe the person carefully. Is he crossing his arms because he does not enjoy my company or is he just feeling cold?

Is he scratching his nose because he is hiding something from me or because it is just really itchy?

How To Spot A Liar

And since we are already talking about lying, you must know that there are a number of ways to spot a liar. Among the most obvious are in their smile and through eye contact.

Experts would say that a genuine smile is impossible to fake. Everyone knows how to smile for the camera and perhaps this is also something we use when we greet other people. But a genuine smile is different because the emotion shows in a person's eyes.

People who are conscious that they are lying may try to cover up their body language. They will do this by trying to maintaining eye contact. However, this may result in having too much eye contact that does not look natural. Their body may become stiff instead of being relaxed. A stiff upper body will result because of this.

Step 7: Be aware of your body language. What is your body telling you about how you are feeling about the conversation? Is it saying that you are enjoying it, fully engaged, bored or uncomfortable?

At the same time, be aware of the other persons' body language to determine how they feel and how engaged they are in the conversation. Think of what their arms, legs, shoulders, and head are doing.

Chapter 13:
Getting Past the Small Talk in Less Than 2 Minutes

Like it or not, a conversation is indeed verbal tennis. It doesn't have to be a quick match. The quality will determine the length of the conversation.

Generally speaking, the person initiating the conversation can expect to do 90% of the talking for the first two minutes. After then, the conversation (if you've reached the hook point) will be much closer to 50/50 talking.

If you're just throwing around light questions and no one is digging deeper then not much will happen. Small talk will remain small. For example, five of the most common questions are listed below.

- How's are you?

- Where are you from?

- How do you know each other?

- What do you do?

- What did you do today?

It is best to be prepared to answer these questions because they will be asked. For example if you're asked where you're from, have one or two unique facts about the city you're from. If you are asked how you know the colleague your with, know an fascinating fact about that person (that raises his or her value). Your colleague will appreciate it and this will allow a conversation to flow because the listener may ask questions.

For instance, maybe your colleague used to be on Americas Next Top Model, or works at Apple Headquarters, or was the beer chugging champion in college. Of course, be aware of what type of audience you

will be talking to, and make it fun and interesting.

Keep in mind that small talk is good because it allows you to grab on to other words that conversation can branch off from, and good conversationalists should be able to

For example, if the other person has already mentioned that he read a book today, ask which one or which type of book it is. Maybe you've heard of 0r read the book, or can connect if you like the same books. You can ask them what they think about the book, the plot, the writing, and the characters – and even how it relates to their life in order to *really* get to know them. The possibilities are endless. Also with each question you ask, you can even volunteer additional or new information and wait for them to respond or add to it – instead of asking question after question.

The fastest way to connect is to find something in common and let that thread flourish. Similar interests are the easiest and most effective way to develop rapport or a connection.

If your hobbies are different, you can try talking about food or family. Eventually you'll find something you both agree on because *everyone* can relate in some way. It could be that you are able to relate to the other person's family life. Are you the eldest child or the youngest? It could be that both of you have similar experiences when it comes to family.

Again use the small talk questions (or openers from Chapter 4) to find a common thread to connect on within the first two minutes.

Listen

The best thing a great conversationalist can do is listen. Most of the time listening is a learned and developed skill. You must learn how to listen. A conversation is never one-sided. You can't just keep on talking without listening to the other person. Also make sure that you show this. Instead of just nodding, you can say "That's interesting" or offer a comment or question that will show the person that you are listening

and interested.

Keep the positive vibes coming - you should keep the other person feeling great about the conversation to truly make them enjoy it.

There are different other ways to show that you are listening to the person or trying to understand their situation. For clarification, you can paraphrase what they are saying to verify if you understood it right. You can tell them, "So what you are saying is that..." or "It sounds like..."

You can also ask them the implications of their actions through the words, "So that means..." or "So that would result in..."

Another tactic would be to show that you somehow understand their situation. You could say, "That must have been really hard for you. How did that make you feel? Always ask them how they feel, but in a casual way, to keep them from brooding about it.

Encourage also the volunteering of more information. "So what happened next?" or "Tell me more about that" would be proper to extend a conversation.

If you would like to transition to another topic, don't be shy to do so. There are ways to casually do this without telling the other person to stop. Some of the phrases for transition include: "That reminds me of," "When you were talking about," "I remembered...You know, I was just reading in the paper about," "I've always wanted to ask you," "I thought of you when I heard," "Do you mind if I change the subject," and "There's something I've wanted to ask of someone with your expertise."

Step 8: Use Small Talk to get answers from the other person to bounce off of and use to find similarities and build rapport.

After you reach a hook point or a point where you feel a genuine connection with the person (and you'll know when it happens), then continue to use the words they use to get deeper into a conversation; or to open new conversational topics to a deep connection.

Chapter 14:
A Glimpse of Storytelling

The second most common challenge with conversations is transitioning to another topic. Lets say, you built up the courage to start a conversation with a stranger, and after a minute your mind goes blank and you feel like you need to leave.

What if you *really* wanted to stay and the person was showing positive body language, but you just couldn't think of anything to say? Maybe you were distracted by something and lost train of your thought because you weren't in the present moment. Maybe you just couldn't think of anything interesting funny, entertaining to say.

This is where storytelling comes into play. The ability to tell a story is an important skill when it comes to any conversation, public speaking, or presentation. It is usually a learned skill that requires practice. There are certain things you can do to significantly improve you're story telling abilities and hook people into your story within a few seconds.

Here is the simplified version of the 10 Steps that should be in every story. I go into much more detail in Chapter 17, but here is a glimpse of what will be discussed.

1. **Get a story**. If you don't have a story create one. Use the past, present, or future. For example, if you could travel anywhere tomorrow where would you go??

2. **Enjoy Your Story** – love it. If you don't love it then the listener won't. Have fun with your story.

3. **Add emotion** – visualize...

4. **Add Pauses** – this heightens the tension and gives the audience time to *listen*, laugh, and/or respond, and adds suspense.

6. **Use body language** – You know it – your body often says more than your words, so use it!

7. **Use Your 5 Senses To Amplify The Story** – How did it feel when you were looking at that crystal clear water? What sounds were around you? The 5 senses bring the story to life!

8. **Characterization** – bring your characters to life – what personality traits did they have?

9. **Know the audience** - Are you talking to a bunch of children in grade school or are you talking to a stranger you just met in a bar? Relate to your audience.

10. **Make sure there is a point to your story** – Enough said! What is the bottom line?

11. **Write your story and cut it in half** – We're all busy, so KISS – "Keep It Short and Simple"

Step 9: After you've successfully opened the conversation, and are getting positive body language, transition into a story. If you don't already have a few good stories to share, it is time for that to change. Create 3 or 4 stories that include the 10 steps above.

If you already have a few stories, improve on them and make sure they have the 10 steps in them.

Chapter 15:
Conversation Killers

As you've seen there are different ways to start a conversation, and there are different ways to end it -- both good and bad. You want to be the person remembered as a good conversationalist, not the "awkward one" right?

In this chapter we'll discuss how you can avoid conversation killers that result in the premature death of your conversation with others.

So how exactly do conversations end? In an ideal world it should end either because you've covered everything you need to talk about and you leave content and inspired or you have to rush of to another meeting, promising that you'll continue the talk next time.

Other causes are most likely excuses or reasons to get out of the conversation. One of the most common one is, "We have to go to the bathroom." That means something you said was either misinterpreted, awkward, or offended the person.

If you are receiving an unending number of awkward goodbyes then consider rewinding the conversation in our mind, and go through what you did or said and the persons responses. Then, select which things were effective in the conversation, and which things you can toss out the window.

Think about his or her body language. When did he or she start feeling uncomfortable body language? What and how did you say the words that made them feel stiff or awkward?

Religion, politics, and ex's are three topics that you want to avoid when first meeting someone because they often stir up negative emotions, especially if the person has a firm belief that you disagree.

Here are some other things you should probably not talk about unless you are sure that that person is okay with it:

- Jokes that may offend people because of race, gender, weight, etc.

- Educational attainment

- Any subject that displays inequality or may promote discrimination.

You might not be aware of it yet, but it could be the content and not the way you are talking that affects the quality of your conversations, or vise versa.

Notice how you communicate with others, including your body language, facial expressions, words, and tone of voice. Consider what your thoughts are. Are they offensive? Are they insensitive? Are they negative? Did you say something to embarrass the other person?

- **Body language** – did the body language change after you said something?

- **Facial expressions** - what were the person's eyes saying? Where they smiling when they were talking to?

- **Words** - to your words give off a negative or positive vibe? If you use profanity, does it make the other person uncomfortable or do they become more engaged?

- **Tone of voice** - do you sound excited? Do you send nervous? Do you sound amazing? Be aware.

On the other hand, a conversation could abruptly end simply because it was becoming boring or that the two people are not compatible. Still, there are a lot of things that can be talked about and enjoyed by even people who have completely different tastes.

Step 10: Whenever you go to meetings, parties, or social gatherings (including coffee shops, or busy streets) make it a routine or habit to introduce yourself to at least three people. This will get you comfortable talking to strangers, and over time you will meet some amazing people and form incredible relationships.

It's one thing to understand "how to start conversations" and it's another thing to actually do it. I encourage you to go out and do it because knowledge is useless unless you put it into action.

Learning how to start a conversation will involve some practice. Each time you interact, you will get better and can continue to make improvements. After doing it for a while, you'll get into a natural flow and it will feel easy and fun to meet new people. You will eventually see patterns in the ways people respond as well.

Do not be afraid to put yourself in situations where you are forced to talk to strangers. Eventually, you will see what works and what doesn't. You'll understand how people feel about you based on your first two minutes of interaction.

Always remember that communication involves listening, understanding, and observing - not just speaking.

Lastly, get into action – go make new friends, acquaintances, business partners, sex partners, networking buddies, or a romantic relationship – whatever type of relationship you desire. Go test out the steps, and determine what feels right and works best for you.

SECTION III: THE METHOD TO STORYTELLING

Let's say you're in a group of 5 people. One is Mr. Social who always has something to say; next is The Nice Guy who pretty much agrees with everything anybody says; then there's The Drama Queen who always is up to date on the latest gossip, and if there's nothing new, then she'll create something new! And we can't forget about the guy's guy who is always up to date on the latest sports news and is practically a beer snob…

And then there's you, who has the ability to take over the conversation and lead it in any direction you choose. You're the person who knows what to say and when to say it. You're the person who can take something that happened yesterday, or an hour ago, or a year ago — it doesn't matter —and spin it into something entertaining, visually intriguing: a compelling story that people are dying to hear about. You understand what a story needs.

This is you after you're done reading and implementing the strategies in this Storytelling Book that you've decided to invest in. Congratulations on making that investment in yourself. Let's get started!

Chapter 16:
Storytelling

The ability to tell a story is one of the most powerful skills anybody can have. I'm not just talking any story, but I am talking about the ability to take a simple story and turn it around so it becomes captivating, enticing, and leaves the listener either bursting with laughter, feeling on top of the world so that he can go out and accomplish anything, or completely leaving someone in awe, on the verge of tears at how powerful and how much your story touched the listener.

The listener could be someone you just met at a coffee shop that you were drawn to, or it could be your neighbor, or an auditorium packed with listeners waiting to be inspired, or your children as you're tucking them in bed.

These are the skills a natural storyteller has; at the same time, the great news is that ANYONE can become a natural storyteller given the proper tools and strategies (which you're reading now), and willingness to get into action and improve the skill.

Stories are used in every setting, all around the world. They are the backbone to all new relationships, spreading the word about all great new ideas, and keeping listeners entertained.

You've come to the right place if this is where you want to be by the end of this short but hefty read.

What Is Storytelling & Why Is It Important?

I'll give you a brief background on storytelling and its uses before we jump into the methods of how to make a story powerful, inspiring, and unforgettable. The art of storytelling has been around since the beginning of mankind. It can be defined as an ancient art form that allows people to actively express thoughts and ideas in an interactive way that stimulates the imagination of the listener. When Jesus was roaming the earth, he used powerful stories to inspire disciples to

follow him and, in turn, impacted millions of lives for centuries. How powerful do you want your stories to be?

Storytelling is a two way street - You've got the storyteller and the listener. The listener's response to the storyteller often dictates the teller's next move, depending on what type of a response he wants. For example, a good comedian listens to the response of the audience to determine which direction he wants to go next. Does he want more laughter? Does he want an emotional response? Does he want them to be shocked? Whatever type of response he wants, he has the ability to get it by reading and listening to the impact of the story on the audience.

Storytellers use both spoken language and body language to express the events and characters in the story often through physical movement and vocalization.

Presenting A Story

When a storyteller can relate a story to the audience, it causes listeners' ears to perk up. The main idea of storytelling is to relate a story. For example, everybody has errands to run from time to time. Maybe you went to the store to grab some milk and someone's dog in the check out line wouldn't stop sniffing you. Well, people can relate in many ways to this simple story. For instance, everyone has gone to the grocery store, and most people have bought milk before, and I'd imagine some people have been sniffed by a dog (not always in a grocery store). The point is that we can all find a way to relate to practically EVERY story!

Stroking the imagination is key when portraying certain events and characters to the listener. Get descriptive, messy, and specific. The more realistic you can paint the picture, the more likely the reader will listen and remember the story. If the dog sniffing you was gross, how gross was it? Did it remind you of something? What did it feel like when you were being sniffed? Adding these details would add to the

95

juiciness behind it all. One of the most important roles of a storyteller is to stimulate creativity by using vivid imagery.

The interesting thing is that no one person will ever have the exact same images as another person – because clearly no two people have the exact same imagination. It's like you're co-creating and designing the story together. While you're telling the story, you can guide the listener to design and feel whatever you want.

Why Is It Important?

For many years, humans have relied on storytelling to pass their traditions, and share family past-times. Nowadays, the method for storytelling has drastically changed. Today, if you want to reach a larger audience quickly, you can film yourself straight from home and put it on YouTube or Vimeo.com, and your story could be spread across the world in a matter of days. On a smaller scale, you can tell a story to your co-worker, or your child just before bed and each will have a different impact. Below I'll list a few examples of where storytelling is used and for what purpose.

Cultural Interaction

Exchanging different stories from city to city and country to country can be great way to open one's mind and learn more about other cultures. This method can teach both children and adults a lot of things about the world. The stories can push people to want to go see Africa, for example, or can totally scare them and steer them away from getting anywhere near Africa. It depends on what kind of an impact you want your stories to have on the listener.

Storytelling can highlight positive and negative consequences in life. People will also be familiar with their own tradition as well as the custom and personalities of other people.

Social Experience

Storytelling has always been a primary form of entertainment. It can provide a fun experience for both children and adults. People can be so caught up in a story that, before you know it, the person is laughing hysterically, or you glance at the listener and they have an extremely annoyed look in their eyes. Stories can and will elicit emotional responses and are excellent ways to break the ice and immediately connect with one another.

To teach a lesson

Often, stories uncover a gem or life lesson that will only be revealed at the end of the story. With a story, you can take something mundane (such as filing paperwork) and turn it into a beautiful work of art (when you were filing paperwork, and all of a sudden you realized something incredible about yourself).

As you're telling your story, the listener will be influenced by your words, rhythm and tone. You'll come to realize which elements make the stories more interesting and exciting. This knowledge will enable you to improve and highlight certain aspects of the story each time you retell it.

Let's go ahead and jump into what's important here – the steps to telling a good story.

Chapter 17:
10 Steps to Telling a Story

Throughout human history, the greatest leaders, teachers, and entertainers have used stories to communicate a particular message. Storytelling requires you to use different skills to engage the audience and draw them into your stories.

Here are the basic steps that can help you turn a simple story into something powerful and unforgettable.

1. Get a story

If you don't already have a story, or at least something in mind that you want to expand upon, then go grab a pen and piece of paper and let's get you unstuck with some quick brainstorming.

On the paper, write 5 categories: Who, What, When, Where, and Why. Then fill in the blanks to one or all of these questions:

- If I could do anything right in this very moment, I would_____

- If I could travel anywhere tomorrow, I would go to_____

- The thing that made me laugh most is _____

- To me, TV is _____

- When I was (pick the first number that comes to your head), I thought a lot about _____.

- Today I learned _____.

Next, answer the 5 category questions to assist in creating a story (e.g. **Who** was there?)

These are a few examples of things that will get you started with creating and telling stories. If you already have your own brainstorming style, then of course you can go ahead and do that.

2. Enjoy Your Story

You, the storyteller must enjoy what you're talking about. Therefore, be sure you've chosen a story that's interesting, funny, has a lesson behind it, etc.

It is key to have fun with the story and play around with its details – maybe add a touch of sarcasm or lightheartedness. See how it makes you feel as you imagine yourself telling it.

If it provokes the emotional impact you want, then go ahead and keep it as is, only slightly adjusting to each listener. If it doesn't work, throw out the detail you just added and try something new. The key is to play around and have fun with it, because the more enjoyable it is for you, the more enjoyable and entertaining it'll be for your listener.

Aside from enjoying the story, you should also be able to understand the whole story enough that you don't need any cue cards. This will make the process sound more spontaneous and fun. Know how the story starts and how it ends, if you must create changes, do it in the middle of the story.

3. Add Emotion

One of the best ways to tell a story is to add emotion to it. I must admit that it's generally easier for women to do this than men. But men, if you want your stories to be impactful and unforgettable (especially to women) then you must add some emotion - whether it be heartbreaking or the funniest thing you've ever seen! If you cannot add any emotion to the story, the listener will have trouble relating to the story. Here are some tips that can help you add emotions to your stories.

First, close your eyes and try to relive that moment in your life. Actually see yourself doing it or being there as if you were a bird watching from a tree. Visualize and re-experience it completely in your mind.

While doing this, you should be able to conjure strong emotions that you can use in storytelling. When you tell it, relive the emotions as if you're re-experiencing it. The listener will be able to hear your emotions in your voice, so the more you can feel the emotion while telling it, the more engaging it will be. Be passionate about the story to elicit a greater response from the audience.

Keep in mind that when you're trying to inject emotion in a story, try not to overdo it or make it "overdramatic," or your listener will be exhausted just from listening to you. Maybe rehearse it with a close friend to help you gauge your emotional range before telling it to people you don't know as well. Again, it depends on what kind of an impact you want to have and to whom you are telling the story. Will you be telling it to a stranger in the mall, or your boss at work, or your spouse, or a group of college students via YouTube?

4. Add Pauses

Every good storyteller knows that a pause can do so many things. It can heighten the tension of the scene, or simply allow the audience to absorb the information given to them, or give the listener an opportunity to laugh or respond back with a "Really?" "Oh my gosh" or "No way!"

As you're creating your story, think through where you'd want pauses. Try to put yourself in the listener's shoes - if you were the listener and you were being told your story, where would you want pauses?

Where would you need time to think and process what's going on?

Where would you be curious or feel suspense about what's going to happen next?

Add pauses there to hike up the intensity.

5. Use Body Language

Emotions can be translated through body language. Be aware of how you are standing when you're telling the story. How's your posture? Are you standing straight up and confident or serious; are you slumped over and looking depressed?

Take note of how much space you take up when telling your story - are your feet far apart or close together? Generally, men take up more space, which has been recognized as a sign of power and being confident. Are your hands and arms moving as you speak – if so, it can add emphasis. Be sure, though, that they are not moving too much and being a distraction from what you're saying.

Rehearse your story. You do not want to confuse the audience with your movements. A classic technique to master body language is by practicing in front of the mirror. Nowadays it's also common to use a video camera or a smart phone to record yourself, watch the video, and then make adjustments.

6. Use Your 5 Senses To Amplify The Story

The more visually descriptive you can make your story, the more entertaining it will be. Stories are best told if you can both feel and see the story unfolding. Words are powerful, so add visually descriptive adjectives to the story.

For example, if you're talking about a fruit you had for lunch, you could say, "Today I had the most delicious strawberries. As I bit into one, I could feel the juices squirting out," or "As I bit into the orange, it made a crunch sound and I was confused," or "When I first glanced at the perfectly pink peach with a hint of orange and the little fur coming off it, I knew I had to have it," or "I could smell the fresh pineapple from ten feet away, and I glanced over my shoulder and I saw the lady was giving away samples."

Ask yourself:

- How did it feel?
- How did it taste?
- What did it look like?
- What did it sound like?
- What did it smell like?

We will expand on this in Chapter 3 when we talk about metaphors and how powerful they can be.

7. Characterization

The characters in your story are just like real people. When describing them, give them their own personality and unique traits. Emphasize characters using emotions. A simple example would be Little Red Riding Hood, who was very naïve, and the wolf, who was cunning and sly. It adds to the story if you can change your tone of voice, rhythm, and even speed when describing each of the characters. And of course, you can rehearse the story a few times to become more confident with the characters' personas.

8. Know the audience

Are you telling your story to a bunch of kindergarteners? Are you telling it to a few coworkers over lunch? Are you telling it to a stranger in a bar? Think of to whom you are telling it, and try to predict their response and the response you'll receive. Visualization often helps with this. So, close your eyes for a moment and imagine being in the setting you want to share your story, and imagine going through the motions of telling your story. Now imagine the listener's response to your story. Was that the response you wanted? If not, take a moment to rehearse it in your mind until it flows the way you want it.

It is vital for any storyteller to relate a narrative to the appropriate audience. You're not going to be telling a bunch of kindergarteners about something that you might tell a co-worker at lunch. You have to

have an idea of how they will react to your story. Age, gender, professional level, and even religious views are important considerations in choosing a story. In addition, the language you use, and even the tone of voice you use must be taken into consideration. Remember that, even if you are telling a well-rehearsed old story, what might be funny for one group can be offensive for another.

If you're telling a story to a large group of people, the topic of the story should be broad enough for everyone to understand. This principle is also used in stand-up comedy. Comedians use mundane and everyday experiences to make their quips relatable to everybody (such as brushing their teeth, or going to the gas station). You will be able to know if you have chosen the right story through the reaction of the audience, and you can always make adjustments, whether it be with your vocal language, body language, or tone of voice.

A storyteller should always be aware of his audience's reaction and know how to keep the audience engaged and entertained throughout the story. No matter how well you have prepared for it, you can still encounter problems. You should be flexible and creative enough to have a back-up plan ready.

9. Make sure there is a point to your story

We've all heard stories that have been pointless but still kept us engaged and excited because of the person's body language and voice qualities. Afterward, we might be asking ourselves, what was the point of that story?

Stories are always best when the story has a bottom line or point, or comedic punch-line, or a lesson to be learned; if there is not point, the story might not be worth telling. People will usually look for the bottom line or purpose of why the story was told in the first place.

10. Write your story and cut it in half

Often, the storyteller gets too caught up in their own story and loses the listener's attention. As a general tip, write your story the way you want it and then cut it in half. Keep the KISS philosophy in mind. It stands for "Keep It Short and Simple (one of the many variations)". Try to leave only the most captivating and important parts(using the 5 senses rule of thumb) of the story - and nothing else. Some people emphasize too much detail that may be irrelevant to the story.

Chapter 18:
Use of Metaphors

Storytellers use a number of tools to enhance their stories and make them come to life. One of the best skills a storyteller can have is the use of metaphors, which are types of visual images. They allow the listener to immediately design a picture in his or her mind while expressing several things at once. Metaphors not only bring the stories to life, but the listener often feels as if he were there too.

One of the best things about metaphors is that they allow the audience to personally design and create pictures in their minds, and therefore the listeners will likely be more attentive and engaged because they're actively using their minds.

Types of metaphors

Metaphors are often used to compare two unrelated objects and find a similarity between them. This allows listeners to relate to an object or a person, bringing a new understanding to the story. In the following paragraphs, the most common types of metaphors will be listed, and you can choose which type to incorporate into your story to bring it to life.

1. Absolute metaphor

In an absolute metaphor, there is absolutely no correlation between the two objects being compared. For example, when you say, "Her heart is stone," you do not literally mean that her heart was transformed into a stone - rather, you can be describing her as unemotional or incapable of love.

2. Active metaphor

An active metaphor is commonly found in poetry and stories. It is used to provoke a particular thought in the audience. An active metaphor may be mistaken for an absolute metaphor, but in an active metaphor,

there is still a slight correlation between the two objects, such as "You are my sunshine."

3. Complex metaphor

Complex metaphor is used in riddles. It is so complex that it is difficult to understand and decipher the real correlation between the two objects. For example, "shedding a light" may be taken literally as bringing light into a dark area but it can also be used as a metaphor. Shedding a light may also mean understanding a situation.

4. Compound metaphor

A compound metaphor uses adverbs and adjectives to excite listeners. Compound metaphors are also known as loose metaphors, which add descriptive words. An example could be, "He could feel the heat rising."

5. Extended metaphor

This takes a single metaphor and uses different ways to describe it. This type of metaphor is often used when a storyteller wants to create a memorable scenario. The meaning of an extended metaphor is not concealed, but it is very elaborate.

An example of extended metaphor would be from Emily Dickinson's poem, "Hope is the Thing with Feathers," where Dickinson compares the concept of hope with a bird.

6. Pataphor

A pataphor is an extreme form of metaphor that is used to express excitement. For example, "She swam with such grace that the water was left undisturbed by her tail." This pataphor describes a girl who swims as gracefully as a fish. Be cautious with this one, though, because it can also be very confusing and may lead the audience to wonder whether it is really a girl or a fish.

7. Simple metaphor

A simple metaphor uses a single description and is used to convey simple messages and ideas. The storyteller won't have to use any flamboyant words; instead he can state it in a straightforward way. An example would be, "Bob is a dog," or "The school is a prison."

8. Submerged

A submerged metaphor has a deep meaning and requires the audience to have more understanding of the subject. Storytellers should stay away from this metaphor unless they are addressing a specific audience that has enough knowledge on the subject such as, "John's thoughts were on the wing," meaning that he was on a plane.

When people hear a picture being described, they draw up their own unique images in their minds. Metaphors enable a storyteller to convey a vast amount of information and ideas without doing or saying too much. Stories are already powerful enough to elicit an emotional response from the audience, and when they are combined with images, the message of the story becomes magnified and strengthed. They synergize the words in a story, ending up with a beautiful image that will be remembered.

Chapter 19:
How To Talk To Anyone

Stories are shared in every social setting. They bring people together and allow people to connect from all over the world – from a story on the Internet or virtual web meeting to the person you're sitting next to. They form relationships, strengthen existing relationships, and allow people to share their thoughts and experiences. I'll go into strategies in a variety of settings, including meeting new people, storytelling for children, and storytelling for adults in a variety of settings.

Meeting New People

Maybe you want to make a new friend, or maybe you want to begin a new relationship and start dating more, or maybe you want to meet your neighbors, but feel awkward because you don't know how to open the conversation. In this section, I want to talk briefly about three different types of conversation openers, because opening or starting a conversation is the hardest part for 95% of people. I've conveniently titled them:

1. The "Excuse me, do you know what time it is?"

2. The "Well, Thank you!"

3. The "Well, hello there."

One thing I want to mention is that, when opening a conversation, body language and facial expressions are very important. A smile makes a person much more receptive to your approach. You don't have to be smiling the entire time, but 70% is a good amount to show that you're happy to be talking to the other person.

If you're more interested in that, I highly recommend taking a look at my book self-titled _The Power Of NLP_, where I go into details about body language - how feet can tell you whether a person is interested or not; how the movement of the eyes can determine whether a person is

a visual, kinesthetic, or auditory thinker; and how to determine if a person is lying. Let's begin with examples of how to begin a conversation.

1. "Excuse me, do you know what time it is?"

This is a very indirect opener, and it opens (meaning the person will be receptive) 99.9% of the time. You make it seem completely like you have no intention of talking to the person other than that you want the time. It is a very soft and easy way to open any conversation.

After you ask the question, you need to immediately transition (or change the subject). A strategy I've used that has been very successful for me is to be very present and be observant (using your 5 senses) about something about the person you're talking to, or something in the environment (although, mention nothing about the physical appearance of the other person because it might come off as a pick-up).

For instance, you might notice that the person you just met looks or sounds like your brother, or even a friend you met years ago while taking a road trip across America. Notice something around you – how the air smells so fresh, or how cool the weather is today, or that the trees have been changing color so fast this season, or how sunny it is today, or be curious about the shirt the person is wearing or the handbag she's carrying. It is key to use and be aware of your 5 senses when interacting and meeting new people. I've noticed that it is great for establishing comfort and building rapport.

If you want to take it to a deeper level quickly (which is a more advanced skill), notice something about the energy they give off when talking with them, and then mention it to them. Really begin to pick up on the person's words, and be curious about what they are saying and how they are saying it, as well as the message behind the words. This can bring the conversation to a whole new level in a matter of minutes.

Then begin with one of the stories you have created. With time and practice, you'll be able to determine which kind of story (out of your new stash of stories) will fit best in the situation and base it off your mood and the other person's mood, too. You can decide to lighten the mood with a happy story, or build comfort by telling a rapport-building story. You can tell a humorous story (which often builds comfort very fast) to make the person smile and feel good, a thought-provoking story, which often makes the person curious about you, or a wide array of stories that you've created.

After a few minutes, you will feel a hook, or comfort and connection built in the conversation, and you can decide where to take the conversation. Keep in mind, you can use a wide array of indirect openers, but the "Excuse me, do you know what time it is?" will work 99.9% of the time.

2. "Well, Thank you!"

This opener revolves around compliments and gift giving. Everyone loves genuine compliments, and people love receiving gifts. I stress the word "genuine," because most of the time, people can see through a non-genuine compliment based on tone of voice and facial expressions.

If you spot someone you'd like to talk to, notice something about them (again, not about their physical appearance). Maybe you like the hat they are wearing or the eyeglasses they are sporting. It can be a number of things. Then, it is very important to immediately go talk to that person, because if you wait a minute, or even a few too many seconds, you'll begin to get anxious and talk yourself out of it.

Another one is gift-giving (which is classic for making friends with your neighbors and co-workers). Imagine your neighbor – who you've seen once or twice – were to ring your doorbell and surprise you with a homemade apple pie, and introduce himself (and his family) to you and your family. Imagine how good that would feel to actually know your neighbors and become friends. Too often in our generation, it seems

like people get too busy to introduce themselves to the people who should be on the top of the priority list of "people to meet" - the neighbors!

Also, giving a co-worker a gift (which is sometimes against office policies – so check first) is appreciated too. It is a great way to build comfort and establish rapport. For instance, you could bring a coworker (or the entire office) a cake that you baked last night, or a cool new pen that you thought they would like, or surprise them with a soda from the vending machine when you went to buy yourself one. If you haven't already, I recommend just trying it and experiment a little just to see what happens. It's fun and exciting to step outside of your comfort-zone every once in a while. Then, of course, with each of these experiments, you'll want to transition with stories that you've created. This will build rapport and establish rewarding and meaningful relationships.

3. "Well, hello there."

This is a more direct and flirty approach, and it will not open every time - maybe not even half the time - but it cuts to the chase and gets right to the point. This one can be considered more assertive and sometime even aggressive. If you're not comfortable being direct or stepping out of your comfort-zone, you can stick with the first two.

With "Well, hello there," this breaks the rule of not mentioning anything about physical appearance. With this, it's best if you notice something about their physical appearance, and give a genuine compliment.

For example you could say, "Hey, I know we haven't met but I was standing over there and you just have this amazing energy about you. What's your name?" Or "Hey, I really like the way your hair bounces when you move (smiling). What's your name?" Or "Hey, I just wanted to say that you have an amazing physique. What's your name?"

From this point, either immediate attraction will be built, or you will immediately get rejected – which is never a big deal, just move on. The more you get rejected or fail at something, the better you will get and the more natural you'll look; and sometimes you did nothing wrong, and the other person may have just been having a bad day.

Again, if it successfully opens, you can transition into a story to build more of a connection and establish rapport, since you know the attraction is already there.

Each of these ways to open a conversation is highly variable, and I encourage you to create your own. These were used just so you could get a feel of the 3 different ways to open a conversation. A website with some good examples of openers to start a conversation is: http://www.conversationstarters.com/101.htm. Take a look at it if you need some ideas to get started.

Chapter 20:
Types of Stories To Tell

Storytelling for Adults

Begin Stories With A Hint or Question

A good way to capture peoples' attention and begin telling a story is by giving a small hint of what is to come. For example, you could start a story with, "Something hilarious happened at work yesterday," or "The craziest thing happened to me yesterday," or "I was so happy this morning."

Also, questions are an excellent way to get a listener tuned in. They get the listener curious about your story. "Have you heard of......?" or "Do you know what happens when you?" or "What's the difference between?"

After opening or initiating a conversation, a story must follow. There are certain strategies that can be useful depending on whether you want to tell a motivational, funny, or scary story. Adults enjoy hearing stories directed toward what they are facing in life. Below are key tips to telling a variety of types of stories:

How to tell a motivational story

Some storytellers are known to be good motivators. You can use your own life story or talk about people you know to deliver an inspiring story. Watch videos on www.youtube.com or www.vimeo.com for examples. When telling a motivational story, include:

- **A story about survival and/or strength.** Tales about near-death experiences and overcoming difficulties are very inspiring because they show human strength. Motivational stories emphasize human mortality, and also reveal how a person can have incredible strength. Use real life experiences to highlight the fact that people can do anything they put their minds to.

- **Be sincere in delivering your message**. Motivational stories are serious and powerful, so there has to be no artifice in the delivery. Try to communicate with a deep level of emotion and sensitivity.

- **Emphasize emotion.** Emotion is what makes a story remarkable and inspirational. The feeling of hope and despair can help people relate to the story better.

How to tell a funny story

Funny stories are some of the most popular stories, because they bring laughter and humor into the conversation. Here are some ways you can tell a funny story.

- **Relate embarrassing stories.**

- **Don't try too hard.** It is ironic how a person can be funnier when they are not really trying to be. Also, try too hard and your audience may find it annoying and irrelevant.

- **Keep the story personal.** People tend to respond to people who try to humbly relate their stories. The more honest you arc the better.

- **Keep it short.** Short stories tend to be the funniest.

- **Use a particular emotional attitude.** You can choose a particular characteristic or attitude like annoyed or excited and try to live it. You can also sarcastically use the opposite emotion of what you are trying to convey.

- **Don't worry about what other people might say** as you tell your story. Funny stories should sound spontaneous and natural.

How to tell a scary story

Even before the birth of horror movies, people already used horror stories to entertain and scare people. The ability to scare people through stories is considered a rare and special talent. Not all storytellers are able to successfully frighten their audience.

- **Voice.** Your voice can be an invaluable tool in telling scary stories. The tone of your voice will make it easier for the audience to feel scared.

- **Do your homework.** Search for the scariest stories you can find and make a list of them. The more realistic they are, the better.

- **Choose new if possible**. Latest stories are a great choice since everyone can relate to it. Urban legends can also work but some of your audience may have already heard the story.

- **Localize it.** Change the setting of the story to make it seem that the story took place in the same place. You can also tie the story to a local resident. Horror stories about a person's locality can have a different impact.

- **Don't over dramatize.** Avoid using words that you do not often use. As a general rule, you have to make it sound like the story makes you uncomfortable inside.

- **Change the setting.** You can change the setting of the story to make it similar to the one you're in. For example, if your town has a local abandoned factory, you can use that as the main setting of your story. Ideally, when your listeners see the factory, they will be reminded of your scary story.

Rapport-Building Stories

People who have gone through tough situations will feel better after talking about it. If you share your tough stories, it may remind the listener of a similar scenario, and he may want to share his stories as well. It is a great way to get people to open up and encourage them to share their own stories. Also, if you can relate to a person's story, and share your own story, that is powerful for creating a connection and building rapport.

An advantage of telling rapport-building stories is that it does make people feel better, and it also forges new friendships. Often, we can be reluctant to share stories because we don't want to be too vulnerable, but once we do, we can enrich the lives of those who hear our stories. It is difficult not to be appreciative of a person after learning their story.

A Few Tips For Storytelling To Children

Children love to hear stories. They laugh, smile, giggle, and their ears perk up to the sound of a good story. However, children can also lose attention at the drop of a hat. It can take a lot to capture and maintain their attention.

Quick feedback and its absence

One of the greatest differences between child and adult audiences is that children give immediate feedback. If they cannot relate to your stories, or if you are not connecting enough with them, they may interrupt you or leave. However, if you do capture their attention, they settle in a comfortable position and look at you with interest. You can use this as a bar to determine how your storytelling is going and what needs to change, if anything.

Tone

Your tone and voice often convey a lot more messages than your words. You may need to change your tone often while dealing with younger children (a higher tone of voice).

The younger the audience is, the more physical your approach should be. They enjoy you acting the part out, as well as using different accents or tones of voice for different characters in the story.

Chapter 21:
Final Tips to Becoming a Master Storyteller

A storyteller should always have a clear objective of what they want to say, but at the same time, it's good not to be too focused on it. It's kind of like holding something in the palm of your hand, but not squeezing it tightly. Don't always expect your audience to respond the same way, because then you might not get the response you wanted, and it will show in your face, voice, and body language.

Listening

Listening is an important part of storytelling. Although the storyteller does most of the talking, the audience will always find a way to voice what is on their minds. Non-verbal listening, in which the listener displays what they're thinking based on their expressions and gestures, is important for feedback and can give you information on which direction to take the story or continue with what you're saying. If the audience is getting bored, shift the topic of the story or change the tone of your voice to make it sound more exciting.

Probing

Probing is the art of asking the right question at the right time. Throughout the story, you can ask your audience some questions. After relating or telling your story, you can ask your audience about their perceptions and opinions to learn if anything needs to be changed for the next time you tell the story. Do your best to be open-minded and appreciative of what other people are saying, and see it as an opportunity to keep improving your storytelling abilities.

Conclusion

Overall, I hope you understand and see how important it is to be a good small-talker, conversationalist, and storyteller - especially in today's world. These are skills that are developed with practice and experience. If you make the strategies discussed in this book a regular part of your day, even if it's 5 or 10 minutes in a coffee shop each day, you will see and feel the difference with your interactions. Weeks and months down the road, you'll be amazed at how confident you are with your conversation skills.

Overall, after reading this book you now know *what* to do, and *how* to apply the knowledge. Now, simply get out there and talk to strangers, or even family members and friends, or people at work, home, in a coffee shop, or anywhere really!

Matt Morris Books:

1.

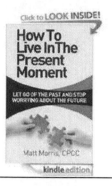

<u>How To Live In The Present Moment: Let Go Of The Past &
Stop Worrying About The Future</u>

2.

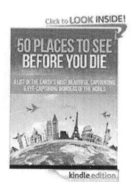

<u>50 Places You Need To See Before You Die: A List Of The
Earth's Most Beautiful, Captivating, & Eye-Catching Wonders
Of The World</u>

3.

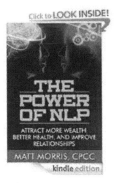

<u>The Power of NLP - Attract More Wealth, Better Health, And Improve Relationships</u>

4.

<u>Positivity: A Step Beyond Positive Thinking</u>

5.

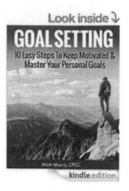

Goal Setting: 10 Easy Steps To Keep Motivated & Master Your Personal Goals

6.

Emotional Intelligence: Understand Emotional Intelligence To Improve Self Management and Increase Your Social Skills

51257223R00073

Made in the USA
San Bernardino, CA
17 July 2017